Merry Christmas To Dad

$3.95

736
Wa

Waltner, Elma
 Carving animal
 caricatures

Merry Christmas To Dad

Carving Animal Caricatures

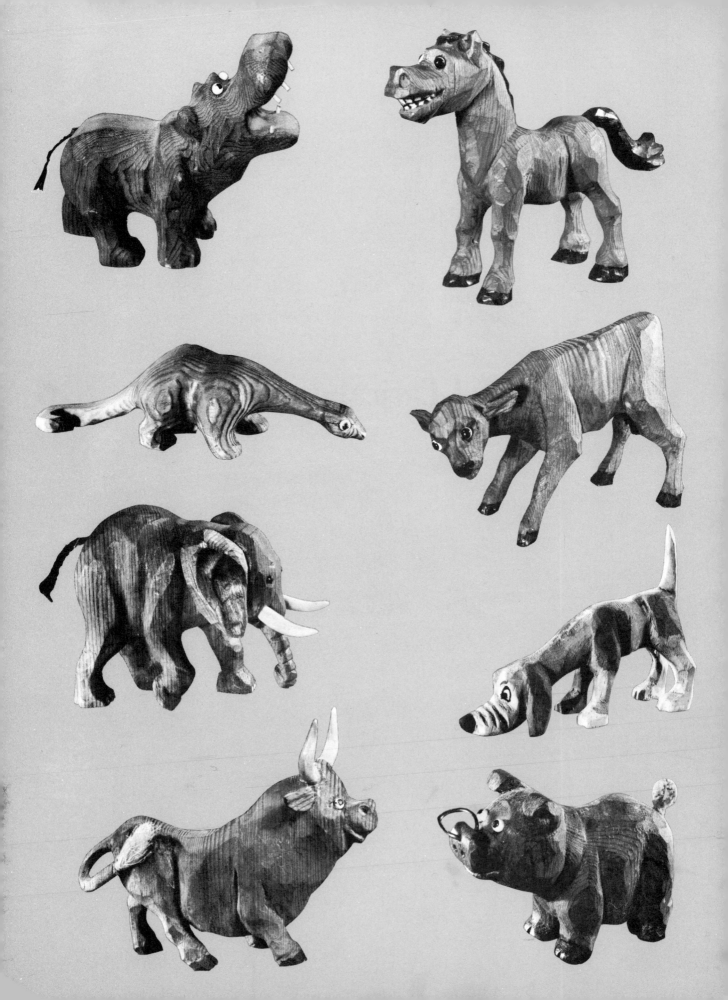

carving ANIMAL caricatures

ELMA WALTNER
Crafts Designer

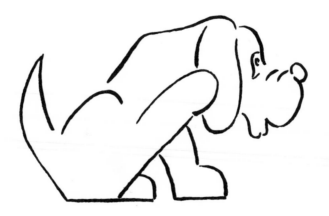

DOVER
PUBLICATIONS, INC.
NEW YORK

Published in Canada by General Publishing
Company, Ltd., 30 Lesmill Road, Don Mills,
Toronto, Ontario.
Published in the United Kingdom by Constable
and Company, Ltd., 10 Orange Street, London WC 2.

This Dover edition, first published in 1972, is an
unabridged republication of the work originally
published by McKnight & McKnight Publishing
Company in 1951.

International Standard Book Number: 0-486-22813-4
Library of Congress Catalog Card Number: 70-184691

Manufactured in the United States of America
Dover Publications, Inc.
180 Varick Street
New York, N. Y. 10014

Whittling and carving is an art, the beginning of which is lost in antiquity. Small wonder — for it is an art that anyone can enjoy and it requires but a few tools. A knife and a sawed-out outline figure may be tucked into a pocket to be brought out and worked on during odd moments.

There is something about whittling that is soothing to the nerves. Often it grows from a hobby to a means of livelihood. A tour through any gift shop will show the value placed upon hand-carved objects. Carving is a most satisfactory means of spending leisure hours. The pride of a job well done and thrill of creation are ample reward for the persistence and patience required in figure carving.

Caricature carving, which is the subject of this book, is a type of whittling that is particularly well suited for a hobby. In carving, as in nearly all forms of caricature, a distinguishing characteristic is emphasized — the long ears of the donkey, the big mouth of the hippopotamus — to give the animal an amusing and appealing appearance.

The profile patterns presented in this book are all in full size. They need only to be transferred to the wood. Use tissue paper or artists' tracing paper to make a copy, which can be applied to the wood with carbon paper or reproduced in cardboard, cut out, and traced around. Detail sketches show the appearance of the figure from several angles. Photographs show each step in the carving of the first figure; in others, only those techniques which are new are illustrated.

The poses and animals presented here are only a beginning in animal caricature. The hobbyist will be able to develop caricatures of other animals and other poses of these familiar friends. In wood carving, as in all hobbycraft, the real relaxation and pleasure come in developing one's own designs and creating something of beauty. What better gift for a dog lover than a carving of his pup, emphasizing its own personality; a horse lover may have his special mount that can be carved — the possibilities are endless!

Some of the figures included were first published in the homecraft section of the "Popular Science Monthly." The author is grateful for the permission to reproduce them here.

Elma Waltner

Foreword

Contents

DEDICATED TO MY PARENTS
WHO BOUND UP
MY CUT FINGERS
BUT DID NOT CONFISCATE
MY CARVING KNIFE

Woods for Carving

Most of the figures in this book were carved of two-inch California redwood planking. (Actually the wood that is commercially known as two-inch stock is only 1 ¾ inches thick.) All of the patterns are proportioned for this thickness of stock. If thinner woods are used, several thicknesses should be glued together to make the stock the required thickness.

Redwood, white pine, sugar pine, western pine, basswood, and cottonwood are good carving woods. In general, the softer woods with less pronounced grain will give best results, especially for a beginner in woodcarving. If hardwoods are desired, gum, mahogany, maple, and black walnut may be used. Hardwoods have more beauty, but split and crack more easily than the softer types.

In selecting the wood, avoid knots or burl grain. Place the pattern in such a manner that the grain of the wood runs parallel with the thin portions of the design; the legs, tail, neck, or in the case of the elephant, the trunk. In some figures, it will be impossible to have all appendages arranged with the grain. In such cases, carve these pieces separately and attach them to the body. Drill a hole in the body and shape the end of the piece to fit, then glue in place. If carefully done, the joint will scarcely be noticeable.

All of the carving can be done by hand with the knife. However, it is much easier to cut out the profile figure with a bandsaw, jigsaw, or even a hand coping saw. If the power equipment is not available, the wood may be cut close to the pattern line with a handsaw, eliminating much hand cutting with the knife.

For the actual carving, a pocket knife or carver's knife is all that is needed. Choose a knife with a strong blade of fine steel that will take and keep a keen edge. The handle should fit the hand comfortably. The author's favorite knife closely resembles a paring knife and has about a four-inch blade. The knife is the only tool really needed for carving, but a small set of carving chisels is handy for some types of cuts.

The knife should be kept razor sharp at all times. A dull knife is more dangerous than a sharp one, for a dull blade is likely to grab or slip in the wood. Hold the knife firmly. At first the hands will tire quickly and blisters may develop at the pressure points. Protect these tender spots with adhesive tape until they become calloused and toughened.

Water colors or small cans of enamel will be needed to make the decorative markings on the figures. Shellac or varnish will make a good all-over finish. A half-inch brush and a smaller artists' brush will also be needed for finishing the figures.

Tools for Carving

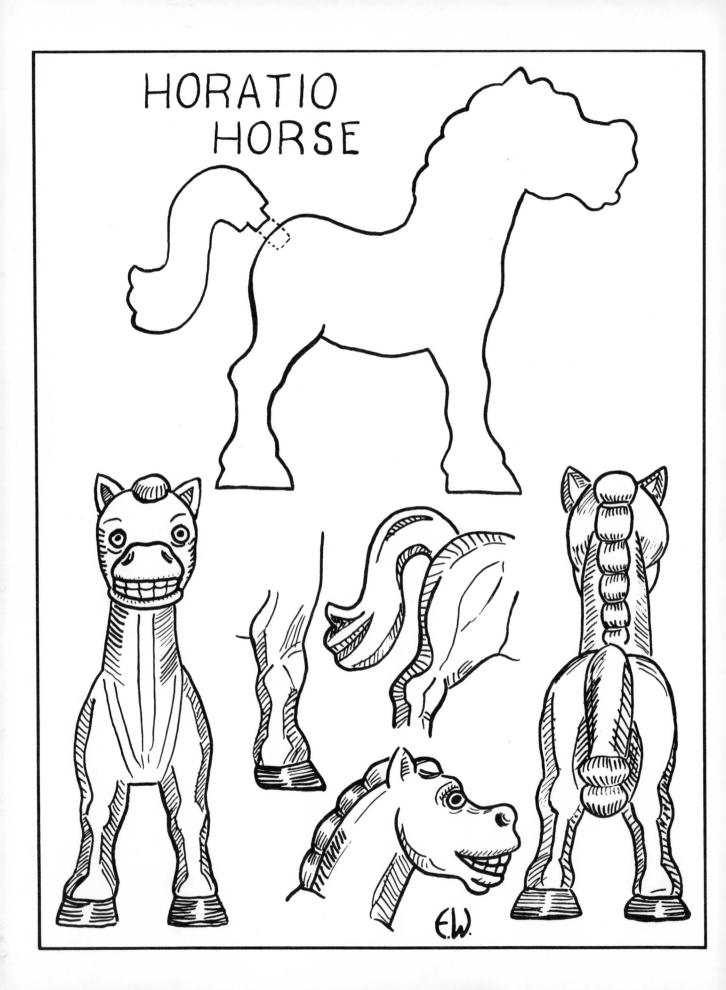

HORATIO HORSE

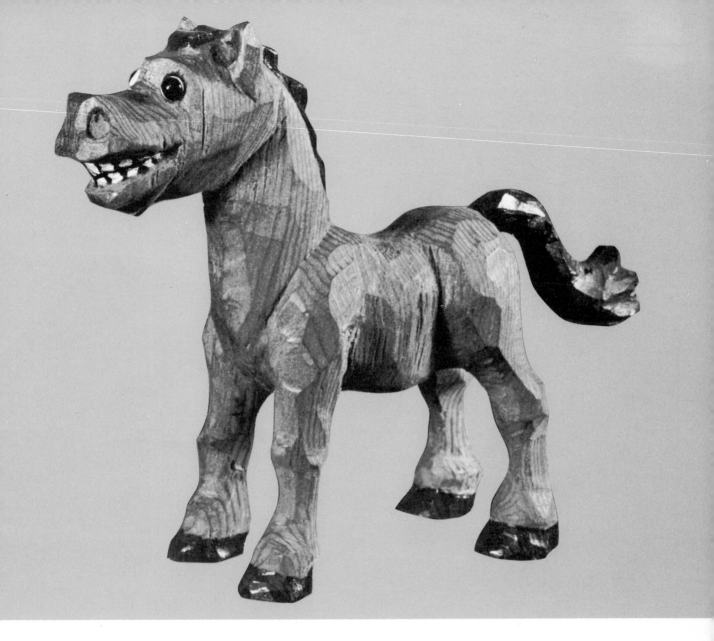

Horatio was carved of California redwood. The pupils of the eyes were painted black, as well as the mane, tail and hoofs. The nostrils and lips were red, the teeth white. The markings on the teeth were made with India ink over the dry white paint. The entire figure was finished with shellac, bringing out the rich reddish color of the wood and resulting in a pleasing appearance. He is four and one-half inches tall, about five inches long, and, of course, two inches wide. With his wide "horse-laugh" he makes an excellent center-piece for a party, or a decoration for a desk or den. He would make a good remembrance for the loser of a bet.

Horatio Horse

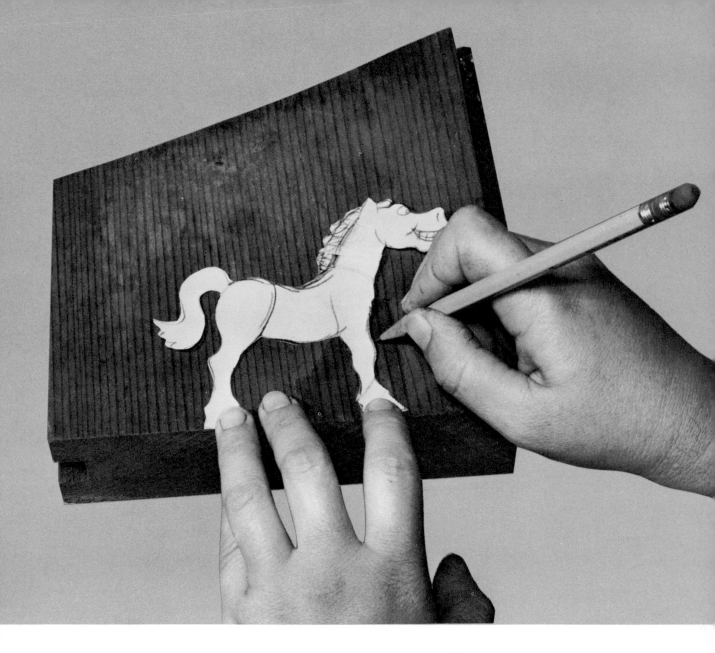

...step 1

Transfer the pattern to two-inch redwood stock. Use tissue paper to trace over the outline in this book and use this pattern over carbon paper. It is also good practice to cut out the pattern and either trace around it or glue it to the wood. If carbon paper is used, dark yellow will be most satisfactory since the redwood is fairly dark.

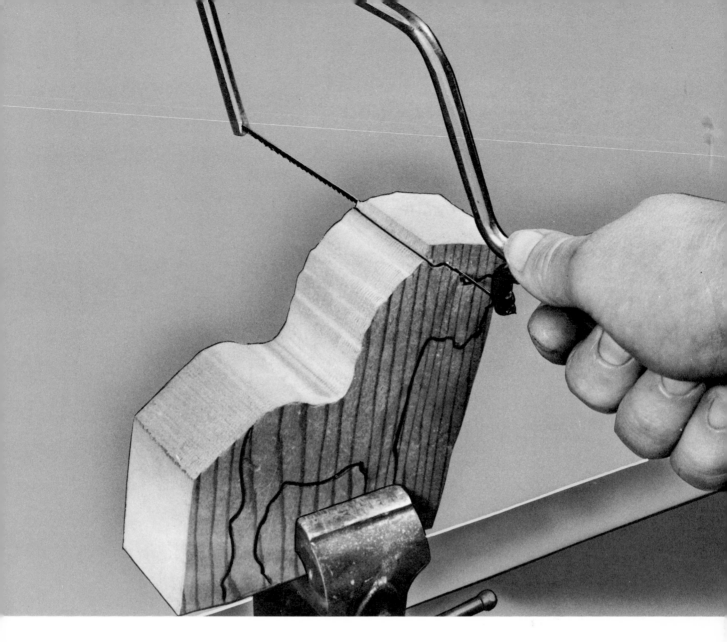

Saw out the profile figure using a band saw, jig saw, or coping saw. Be sure the saw blade cuts in a straight up and down position so the edges of the figure do not slant.

...step 2

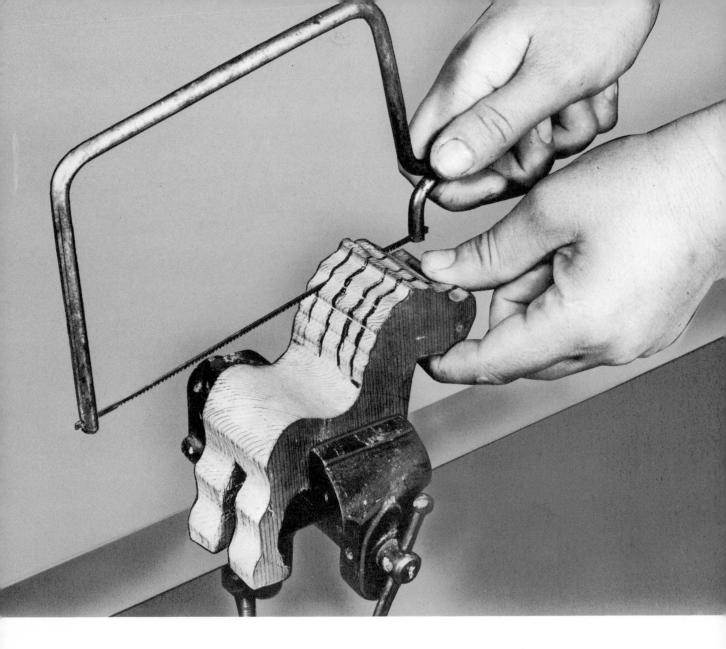

...step 3

After the figure is sawed out, clamp it in a vise and remove other surplus wood with a hand coping saw. The wood between the legs can be removed in this way, and the head and neck may be thinned down. Draw guide lines on the figure to show how much wood to remove.

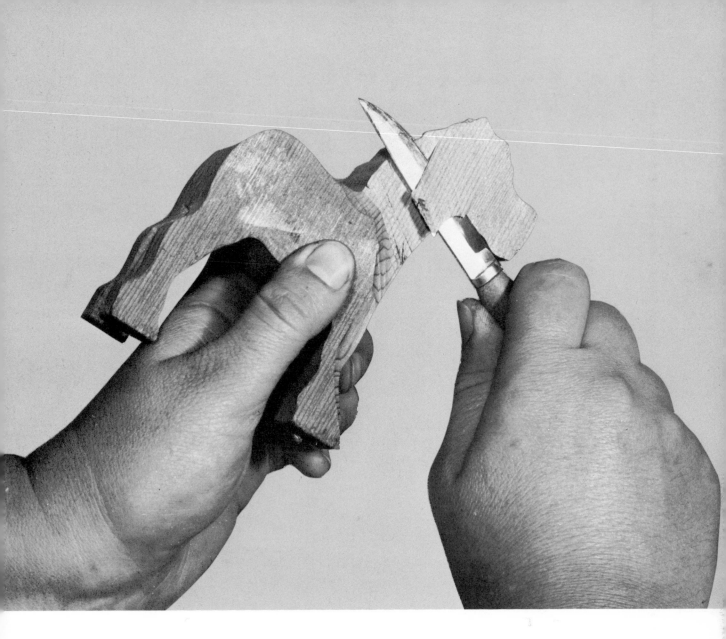

Make rough cuts, holding the figure firmly, and cutting away from the body. Remove as much wood as possible with each stroke, but never cut so much that it splits in front of the knife or requires too heavy a pressure to make the cut. Be careful that the grain of the wood does not lead the knife into part of the figure that should be saved. Hold the figure firmly behind the sweep of the knife.

...step 4

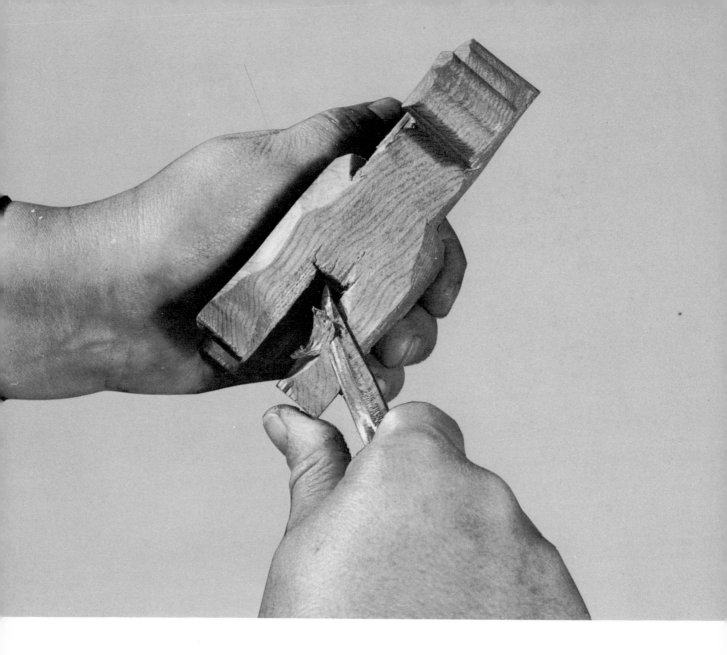

...step 5

To carve the legs on the inner side, make cuts up from the hoof nearly to the body and complete the cuts by cutting down from the body. Carve the hind legs in a similar manner.

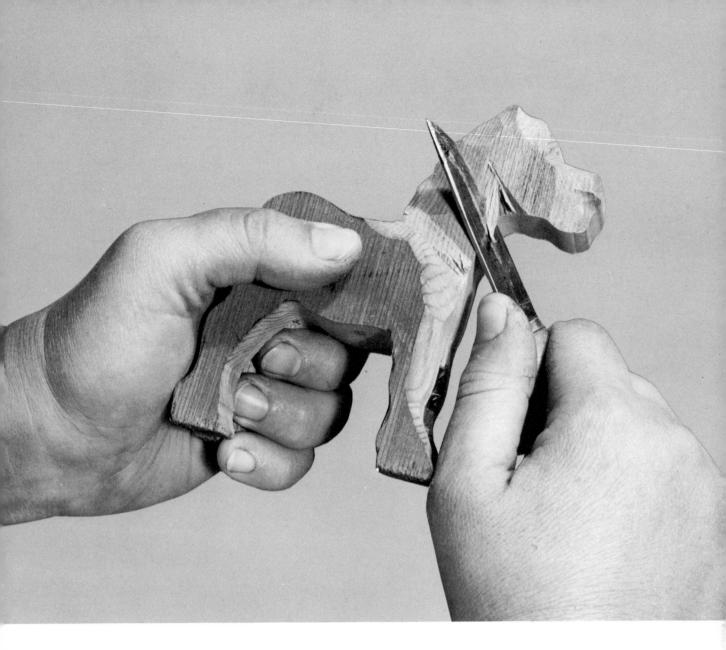

Use the V-cut to remove portions between the ears and where the neck joins the body. Force the knife blade into the wood at an angle, cutting as deep as desired. From the other side make a similar cut to complete the V-notch. It may be necessary to make several cuts to make a very deep notch or groove.

...step 6

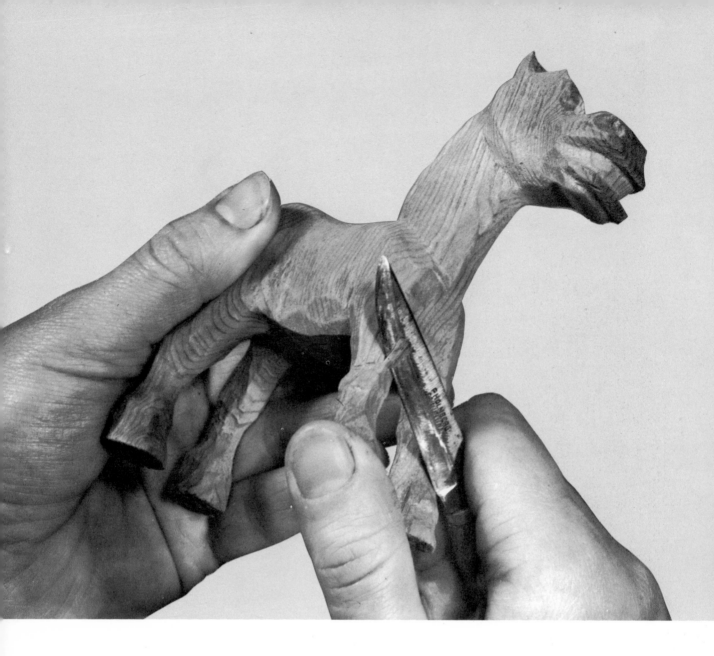

...step 7

Continue carving the figure, turning it often and working on it as a whole, rather than completely finishing one portion before beginning another. Carving it in this way makes it easier to keep the animal in proper proportion, since it is possible to watch the figure take shape.

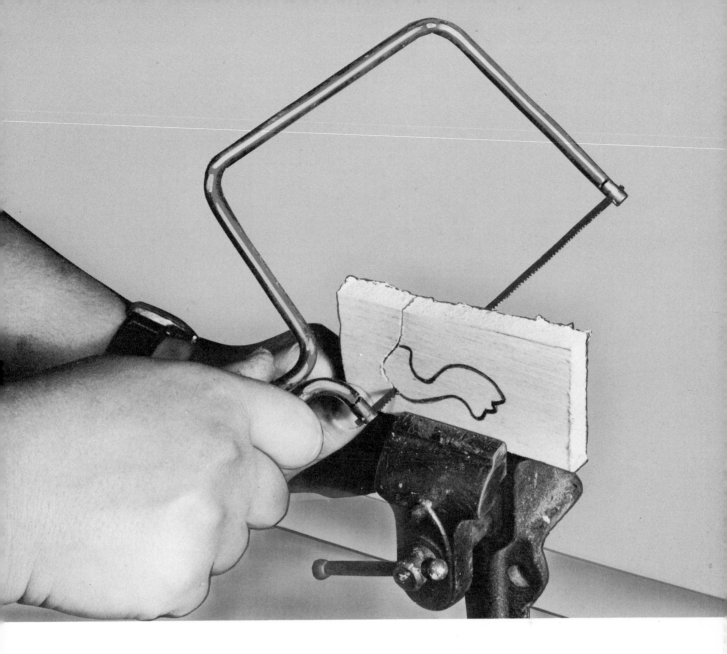

The tail is carved of white pine and fitted to the horse's rump. Because of its shape, part of it must be cross grain. White pine will not split or break as easily as redwood. Saw the tail out of three-fourths inch stock.

...step 8

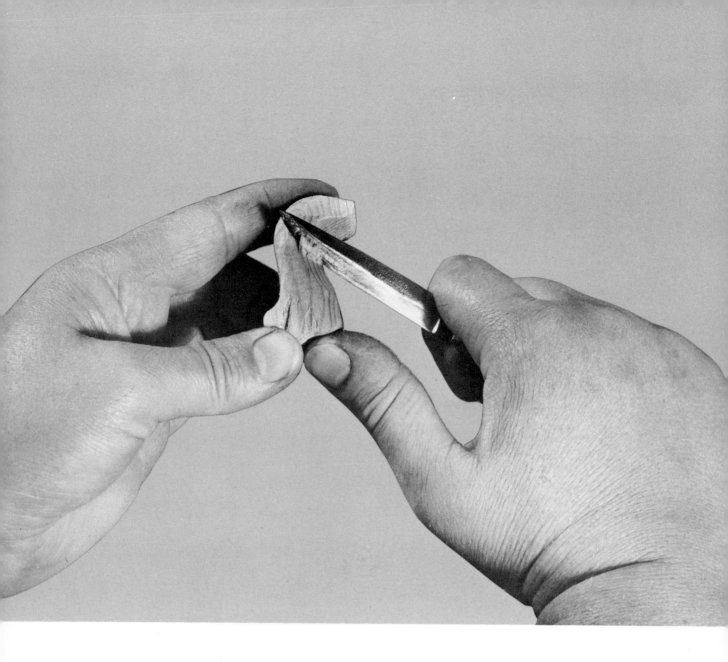

...step 9

Carve the tail. In the photograph above, a small finishing cut is being made. In this cut, the blade is drawn toward the body while the thumb of the knife hand presses against the figure, just as in paring vegetables. Use this cut to finish the contour of the figure, removing only a small chip of wood at each stroke.

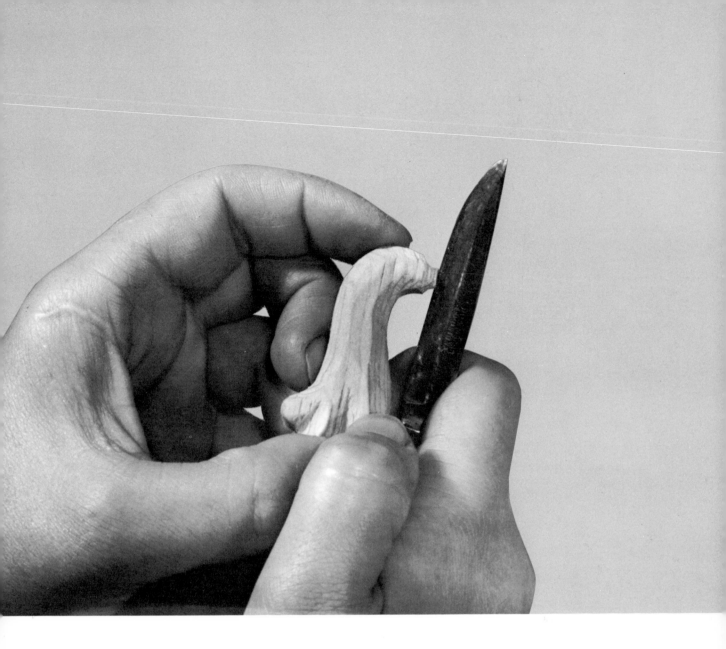

Shape the end of the tail, where it joins the body, into a round peg so that it may be fitted and glued into a hole in the horse's rump.

...step 10

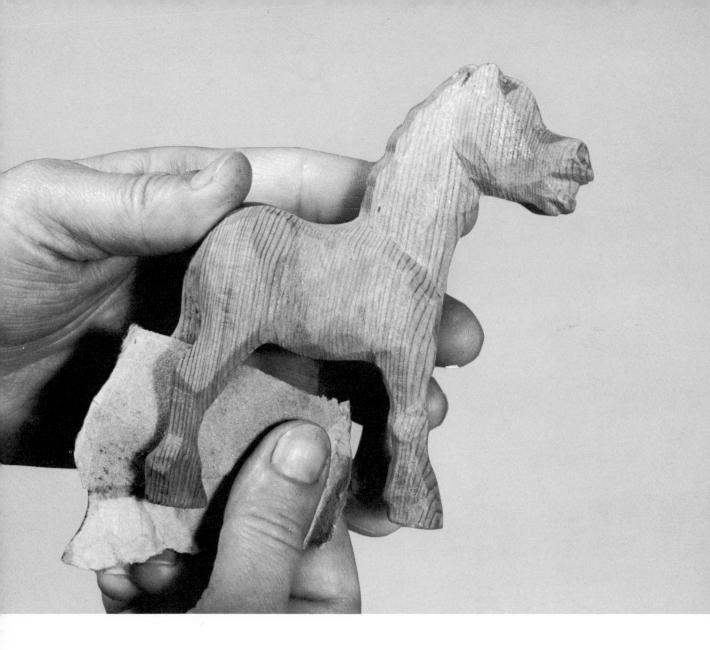

...step 11

After the carving is completed, sand the piece to remove any roughness. Merely smooth the edges, leaving the carving planes. The rather rustic appearance adds charm and appeal to the animal caricature.

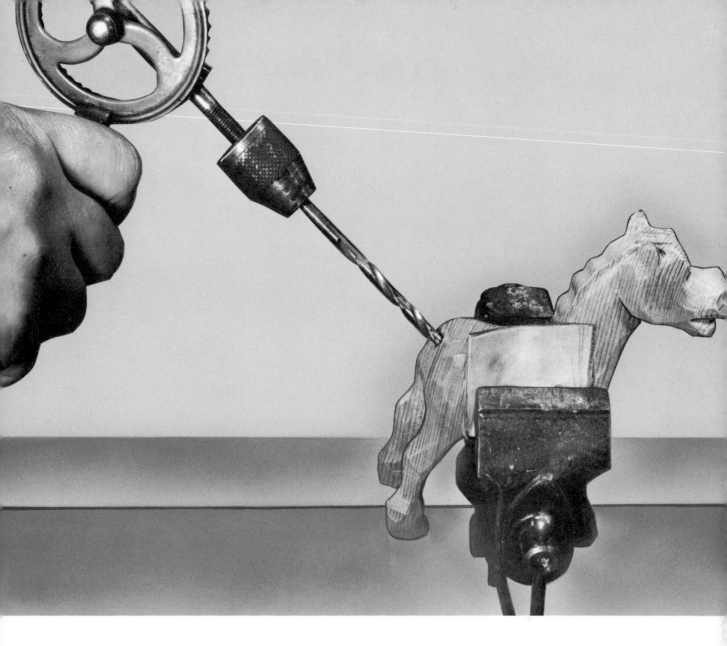

Drill a hole in the horse's rump, being careful to drill at the correct angle for the way in which the tail has been carved.

...step 12

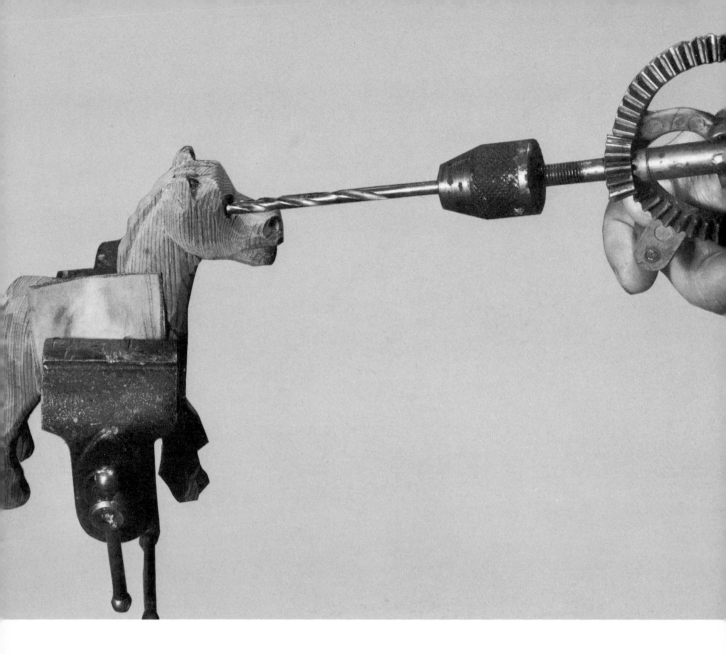

...step 13

Drill eye sockets with a small drill or countersink. White map pins make good eyes. They may be pressed in place and held by the tightness of the fit, or a small amount of glue may be dropped into the socket. Small beads also may be used for eyes.

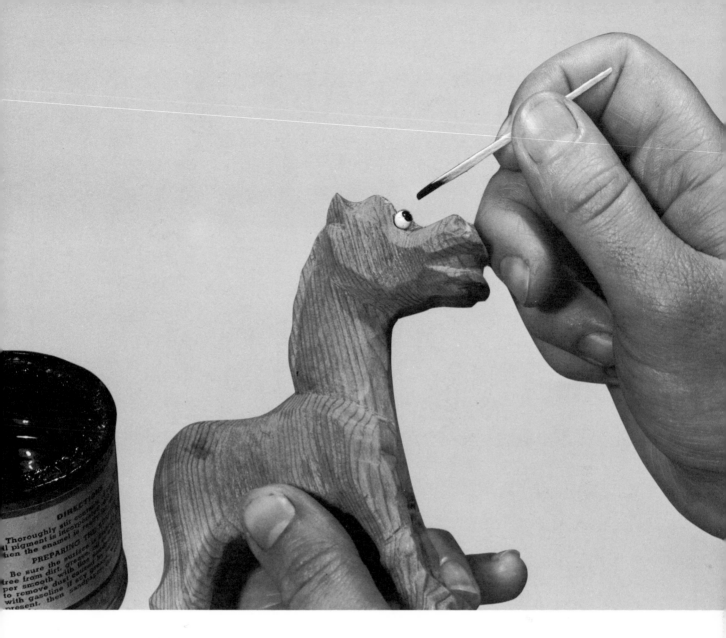

Paint the pupils of the eyes black, as well as the mane, tail and hoofs. The nostrils and lips are painted red and the teeth white. The tooth markings are made with pen and India ink over the dry white paint. A coat of shellac over the entire figure gives it a rich reddish color which is very pleasing. This type of finish may be used for all of the redwood figures, and is satisfactory for other dark hardwoods. Figures of white pine require a paint finish.

...step 14

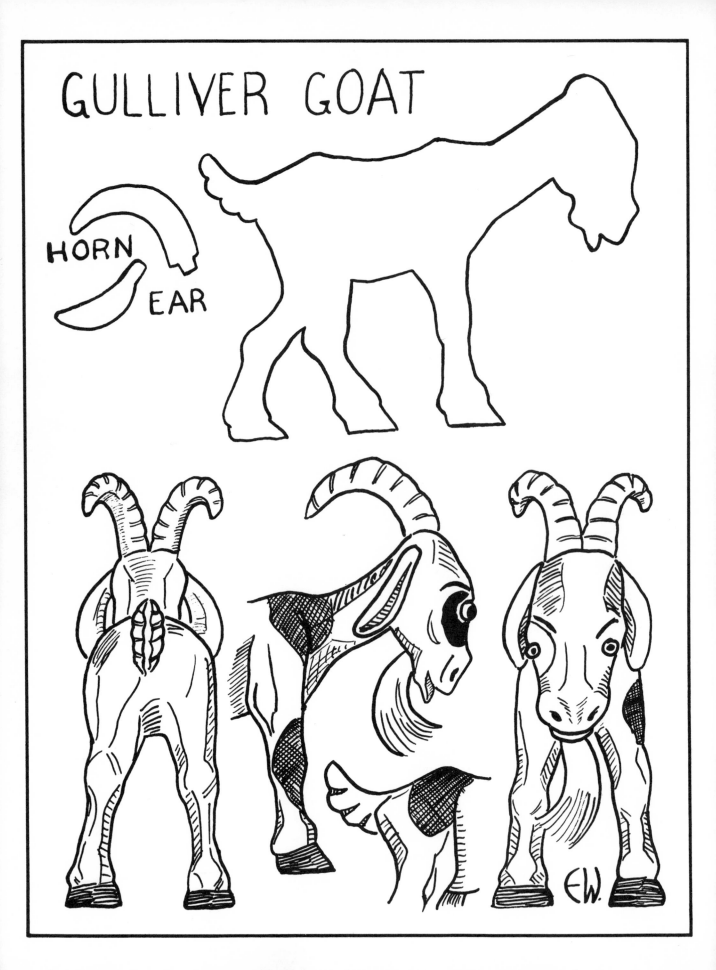

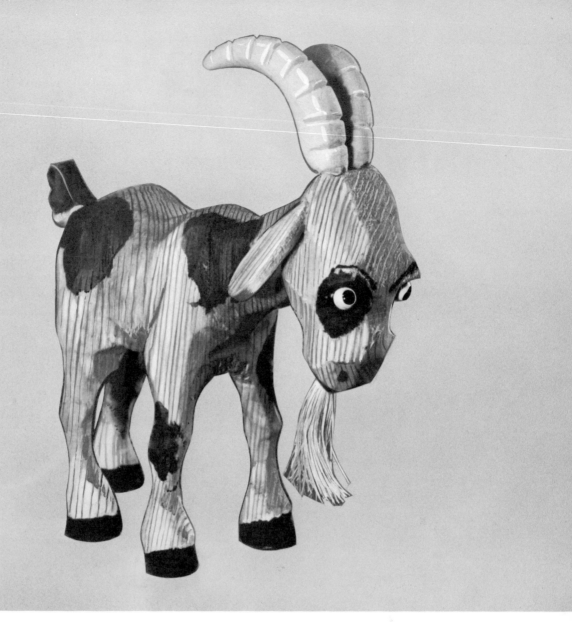

For the figure of Gulliver, white pine seems to be a more suitable material than redwood. Pick a piece of two-inch planking (remember that it is only 1 ¾ inches thick) that is free of knots or pronounced grain. Horns and ears are carved separately and glued to the finished figure. A short length of stiff hemp wrapping cord, raveled out, makes a very convincing set of whiskers. Gulliver, with his pugnacious appearance enhanced by his one black eye, is good for a round of laughs on any occasion.

Gulliver Goat

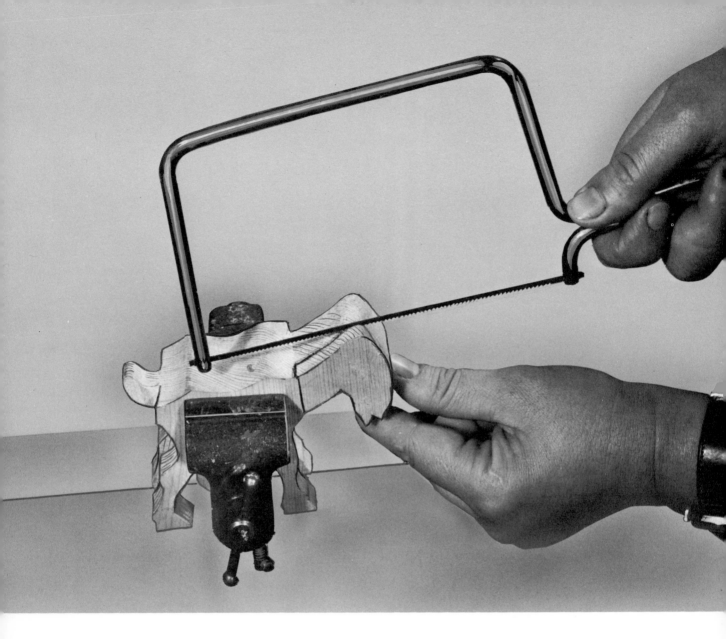

...step 1

Lay out the figure on the wood stock in the same manner as Horatio. Saw out the figure, then saw away the surplus wood at the head and neck, the tail and between the legs.

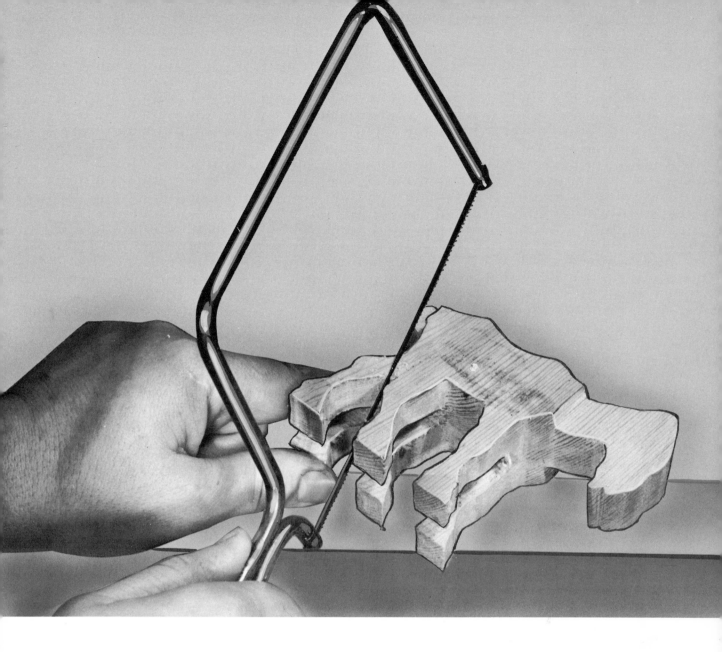

Because the back legs are not in line, the figure will have four back legs when you finish with step one. Lay the animal on its side and saw off one of the legs on the right side.

...step 2

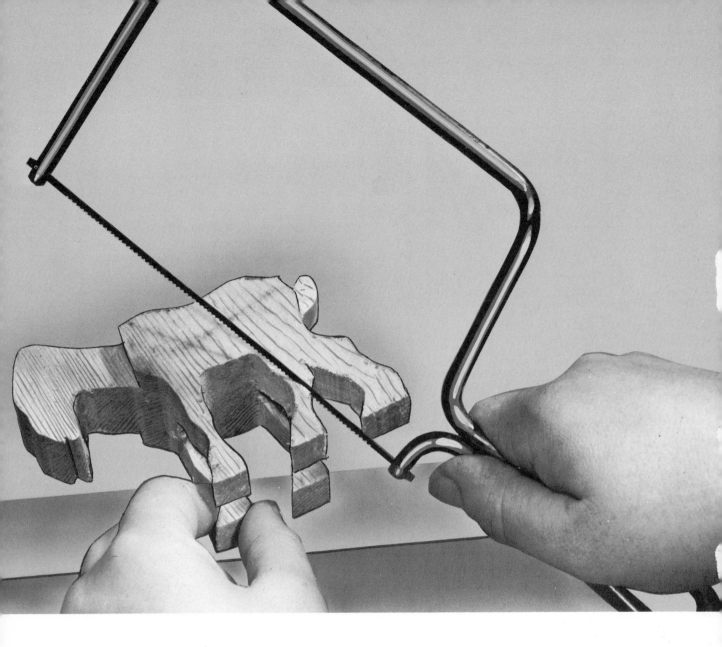

...step 3

Turn the figure over and saw off the extra leg on the left side. It will be noted that the leg on this side cannot be sawed off close to the body because of the leg positions. The stump which is left must be removed with the carving knife.

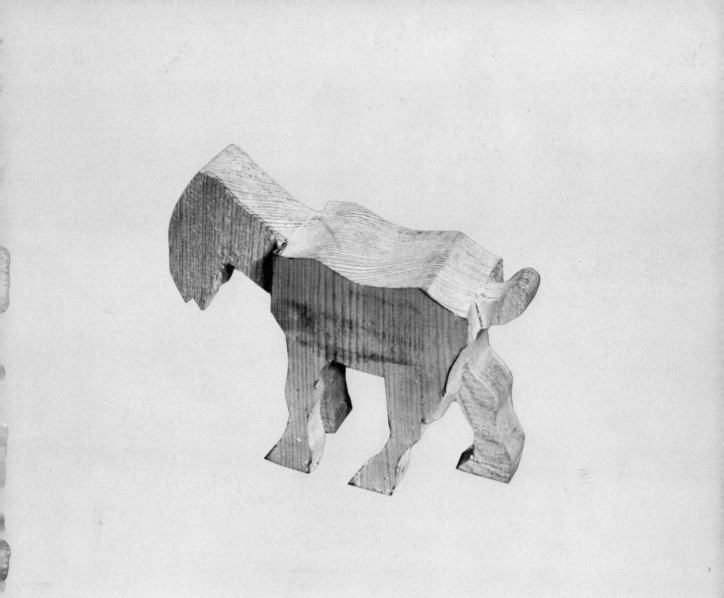

The rough cut figure, ready for carving, presents rather a woe-begone appearance. It is best not to expose poor Gulliver to the criticism of unsympathetic observers at this stage.

...step 4

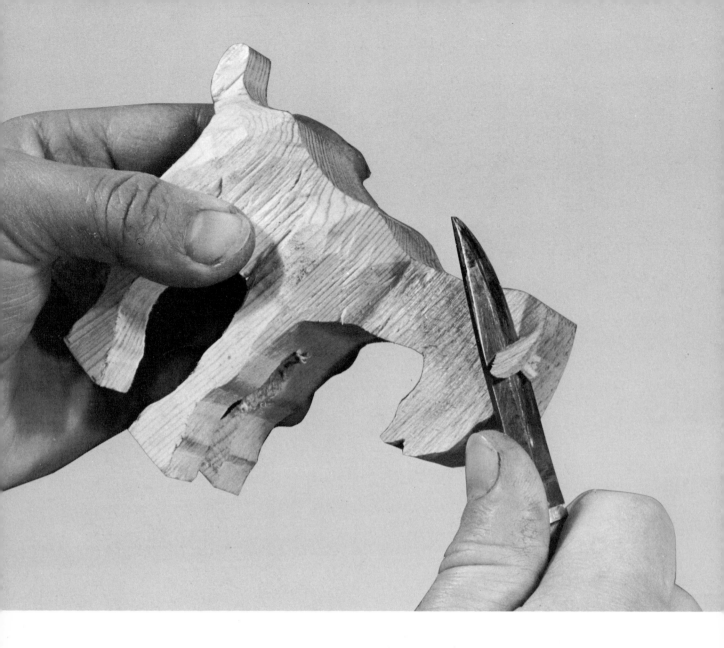

...step 5

Begin the carving by removing as large a chip as possible with each knife cut. Be careful, however, not to take deeper cuts than the knife can conveniently handle or it may stick or slip in the wood.

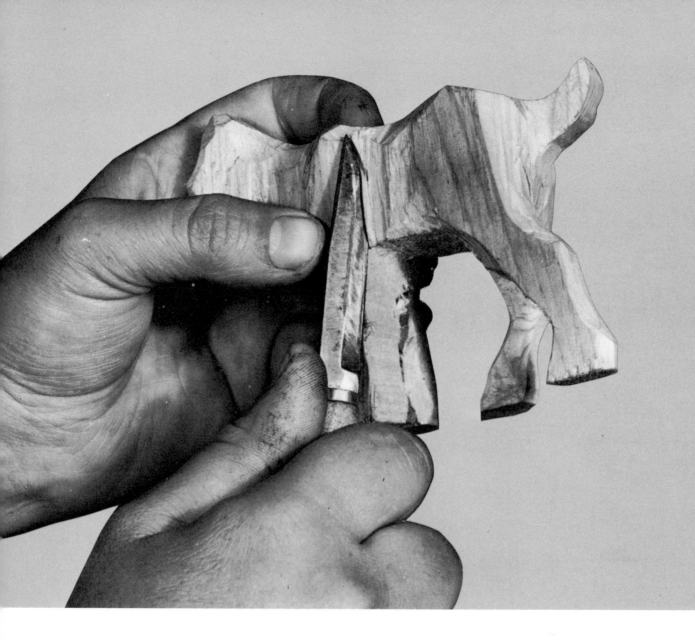

Removing the surplus wood of the body along the leg line involves two cuts. First, press the knife straight into the wood along the leg line.

...step 6

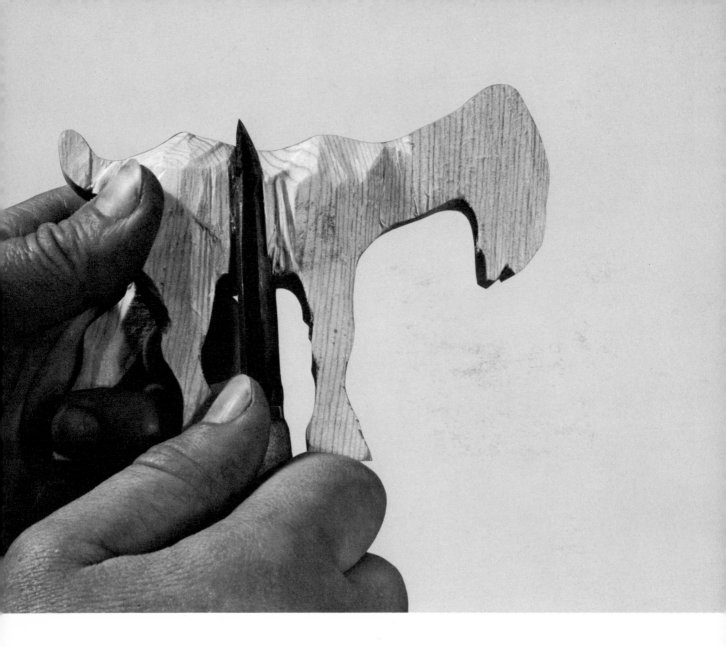

...step 7

After making the straight cut into the body along the leg line, make a sidewise cut along the body to meet the straight in cut. Like the cuts used in removing wood around head and neck, this is a type of V-cut. Repeat the cut until the required depth is reached.

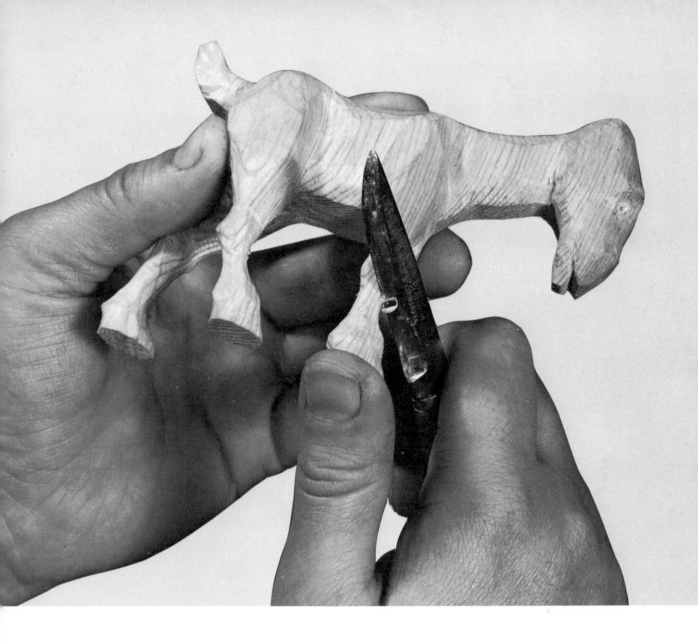

Carve the entire figure, using rough cuts to remove the bulk
of the surplus wood. Turn the figure in your hands often to pre-
serve proper proportions. When making the finishing carving
cuts, remove only small chips or slivers with each knife stroke.
You can always remove more wood but it is another matter to
put shavings back in place when too much is removed.

...step 8

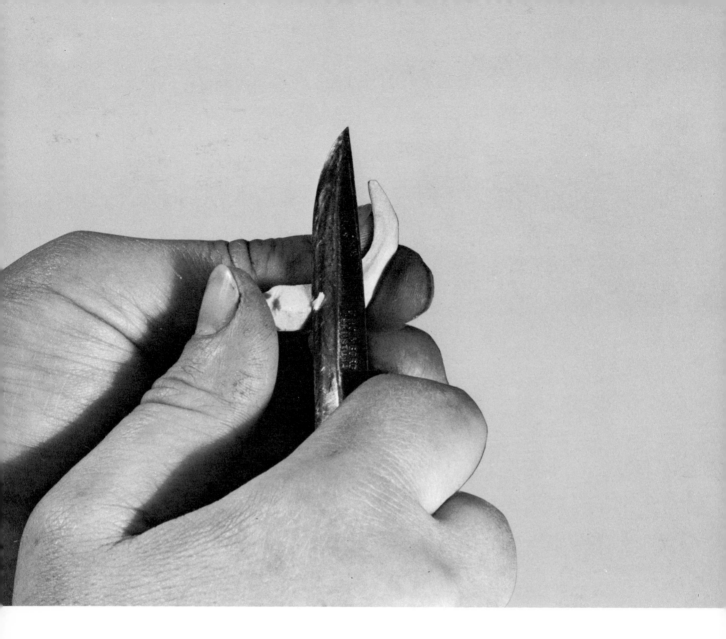

...step 9

Saw out the horns from one-half inch stock. Carve carefully, especially where the grain runs crosswise for it splits off easily. Carve one end to fit into a hole in the head as you did Horatio's tail.

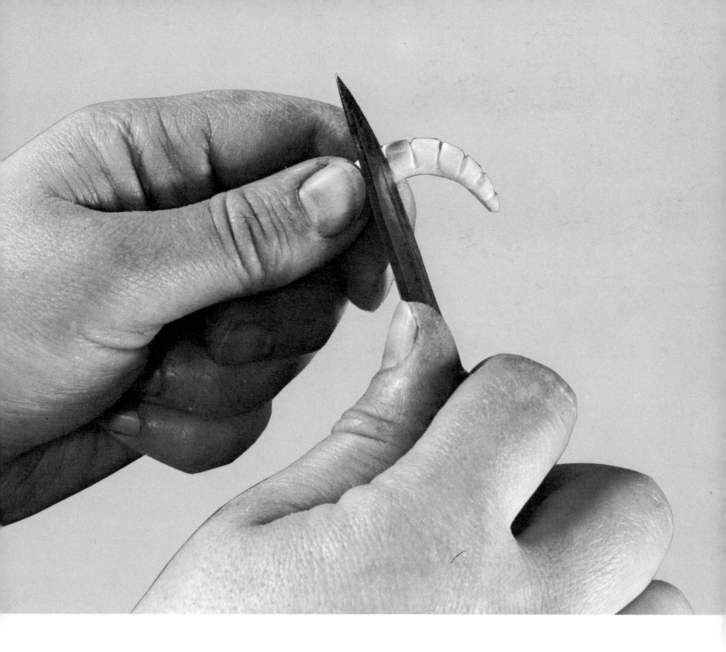

After carving the horns, make circular cuts ringing the outside at intervals of about one-fourth of an inch. Sand the horns very smooth to remove all carving planes.

...step 10

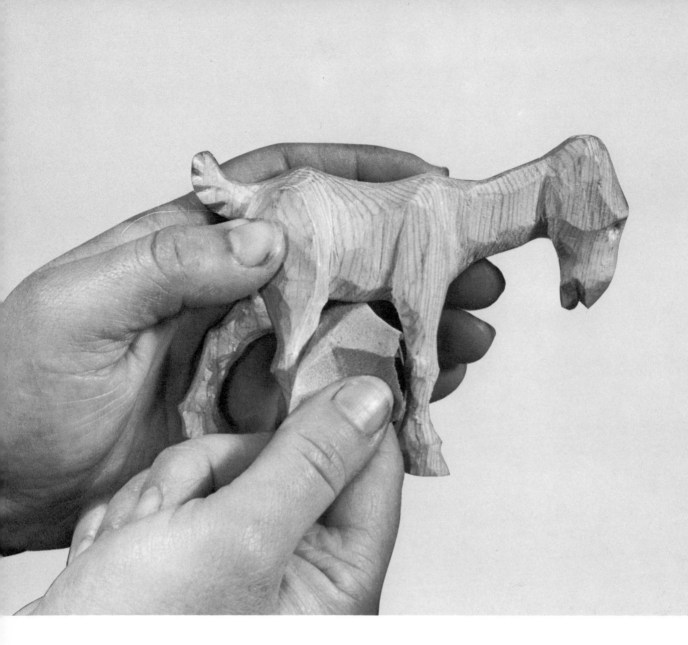

...step 11

Sand the entire figure, rubbing down the roughness but not sanding off the angular carving planes.

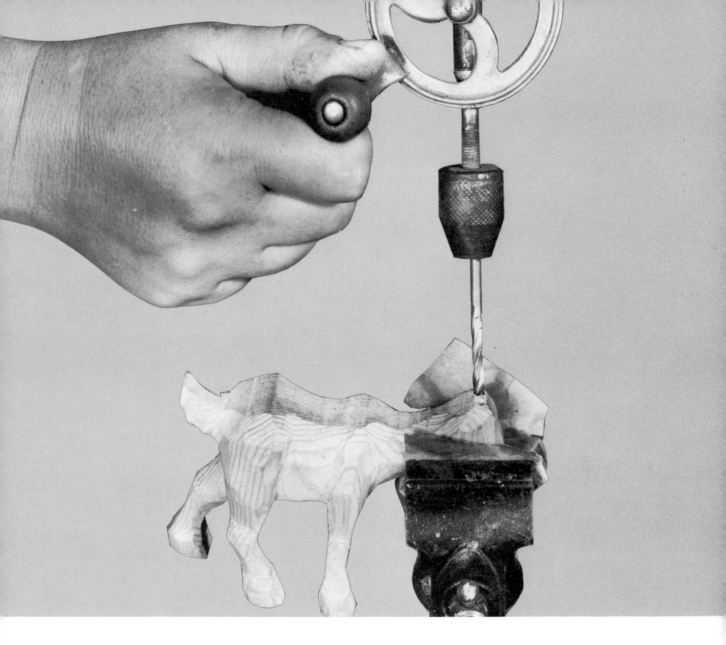

Wrap light cardboard around Gulliver's middle for protection and clamp him into the vise to drill the holes on the back of his head into which the horns will be glued.

...step 12

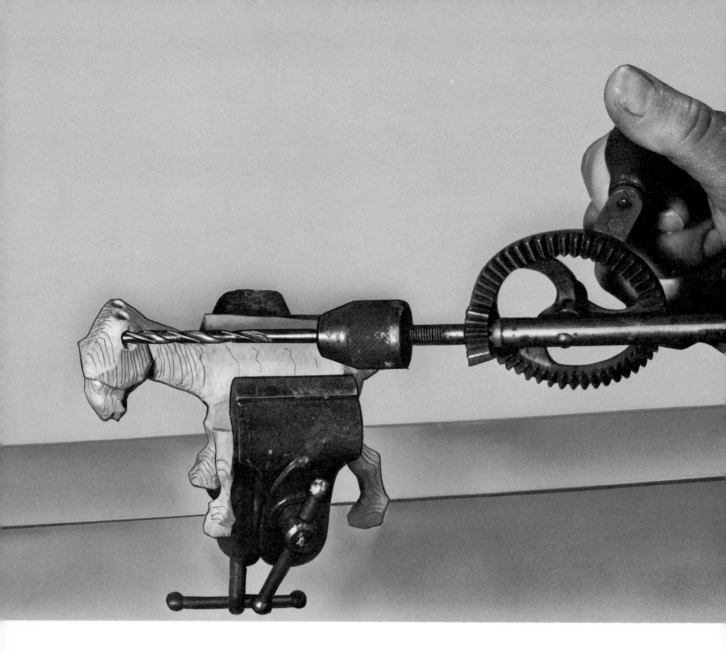

...step 13

Drill eye sockets and the holes into which to glue the ears. The slant at which the ear holes are drilled determines the amount of droop to Gulliver's ears.

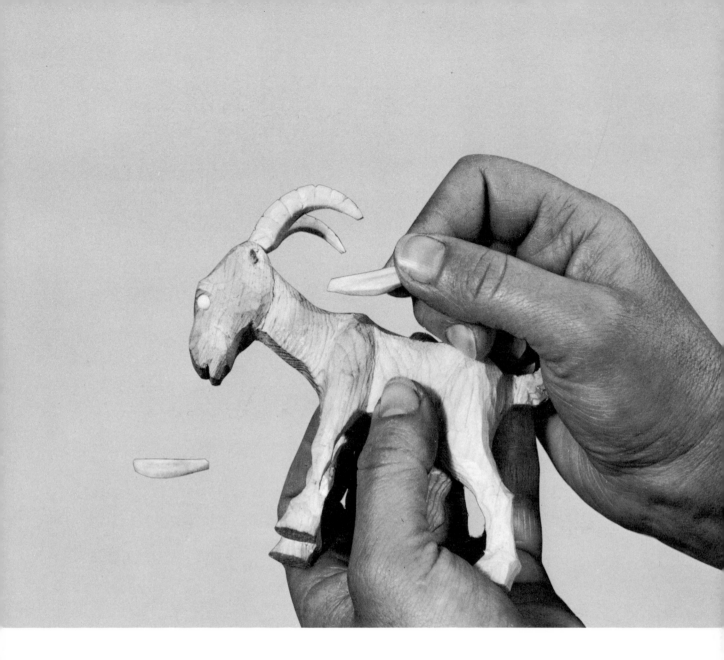

Press the map-tack eyes into place and glue the horns and ears into the holes drilled to accommodate them.

...step 14

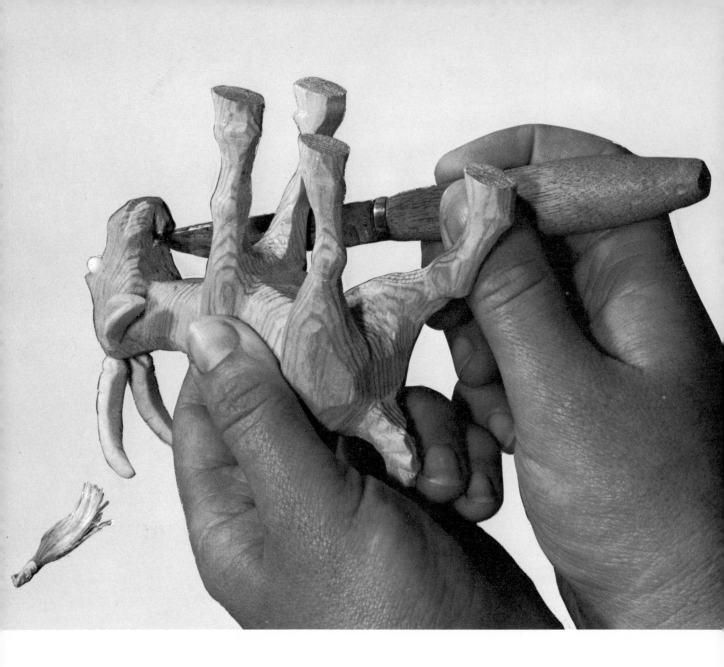

...step 15

Make the beard by wrapping thread tightly around one end of a 1¼ inch length of stiff wrapping twine. Ravel out the twine to make whiskers. Hold the figure upside down and cut a groove on the back side of the chin.

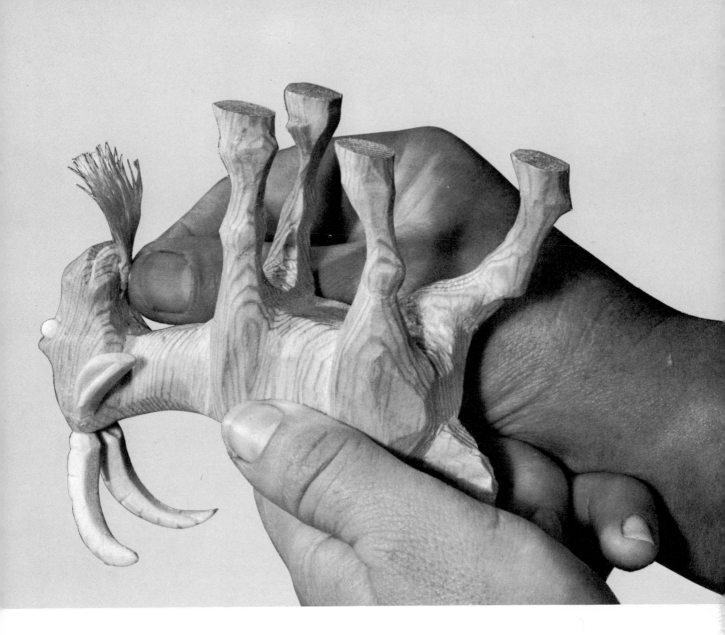

Glue the tied top end of the whiskers into the groove so that
when the figure is right side up they appear to be growing out
of the end of his chin.

...step 16

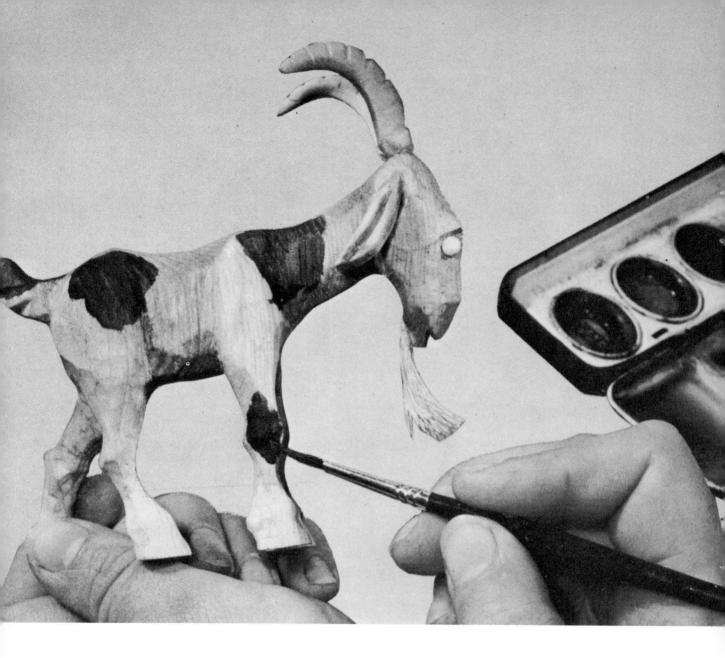

...step 17

Give Gulliver a paint job. Because a dull finish is desired, water color paints are ideal. Paint the entire figure a light brownish gray. Add spots of dark brown.

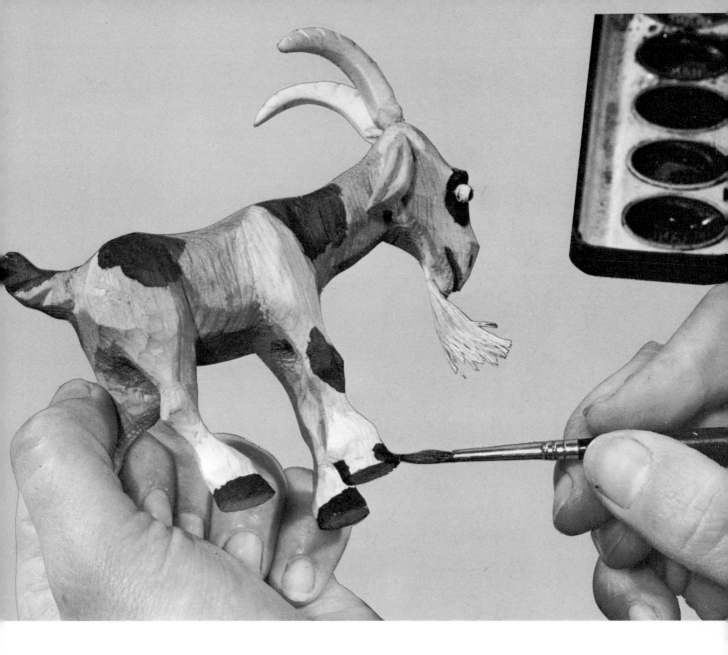

Paint the mouth and nostrils red, the pupils of the eyes black. Enamel must be used because water color will not stick to the white pins. Paint the hoofs black also. Note that Gulliver's right eye has been rimmed by one of the brown spots. This and his beetling black brows make him look as though he is ready to take on all comers.

...step 18

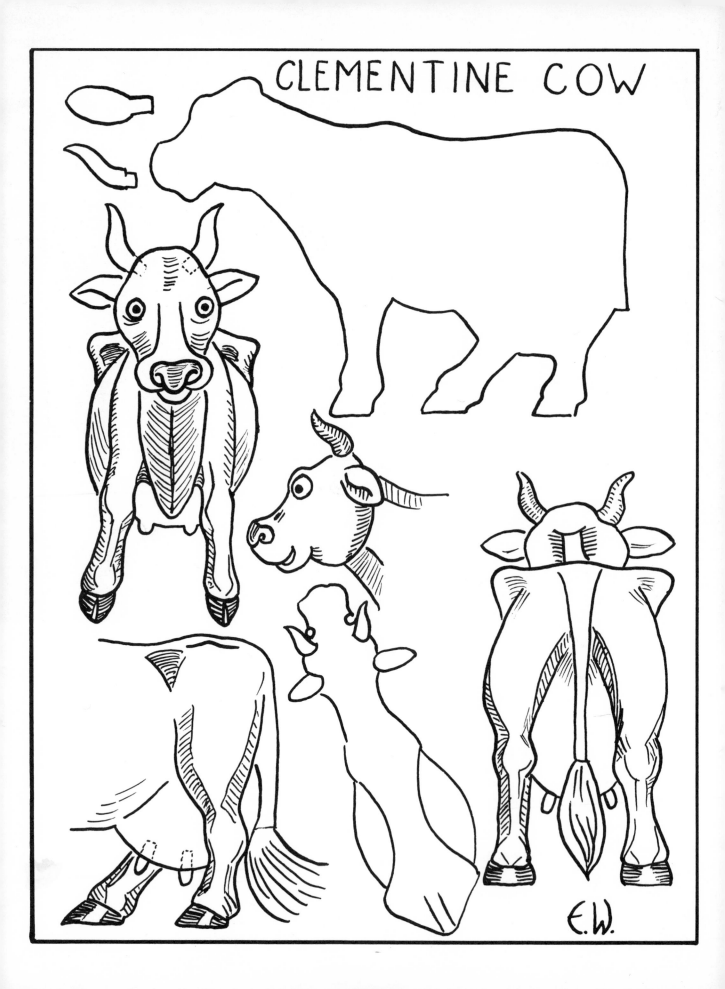

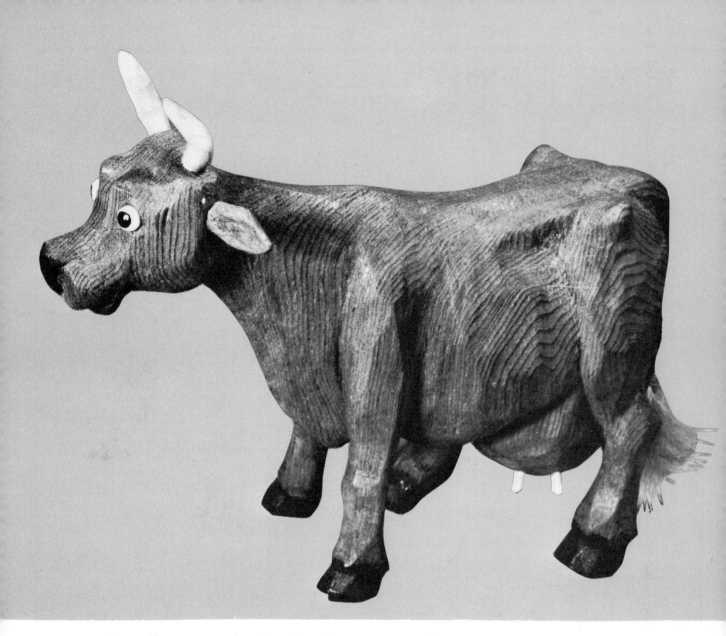

Lay out the profile on two-inch redwood stock, saw it out, and remove as much surplus wood as possible. Cut the horns from one-half inch pine and the ears from one-fourth inch redwood. The identifying characteristics of the cow are the protruding hip bones, the thin brisket, and the cloven hoofs, so give them special attention while carving.

Carve the horns with the twisted curve illustrated. They will need pegs since they are glued into the head. Sand them very smooth to give a true horn appearance. The four teats are short sections cut from round toothpicks. Round the ends and glue the teats into holes bored in the udder.

The brush of the tail is a piece of soft manila wrapping twine about an inch long. Glue it to the tail and ravel the end of the cord, then trim and shape. If the tail is to be black, dip the cord in India ink before attaching it to the tail.

Sand the figure lightly and finish. Paint the hoofs, nose, and pupils of the eyes black. The lips are painted red. The coloring of cows varies with the different breeds, so observe the markings of nature. Finish all over with shellac.

Clementine Cow

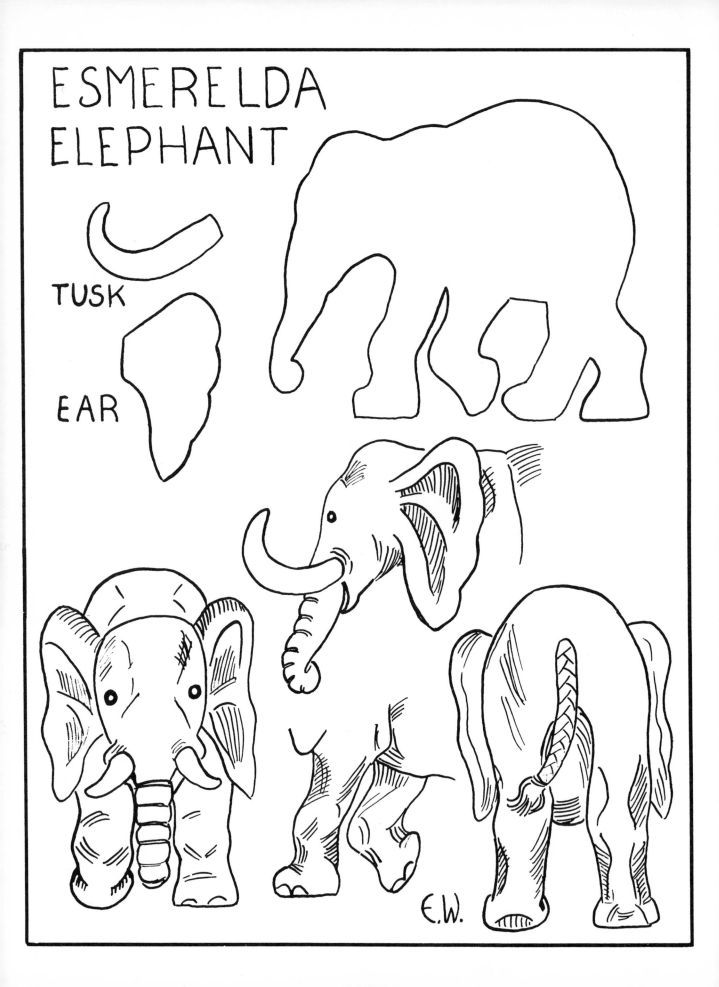

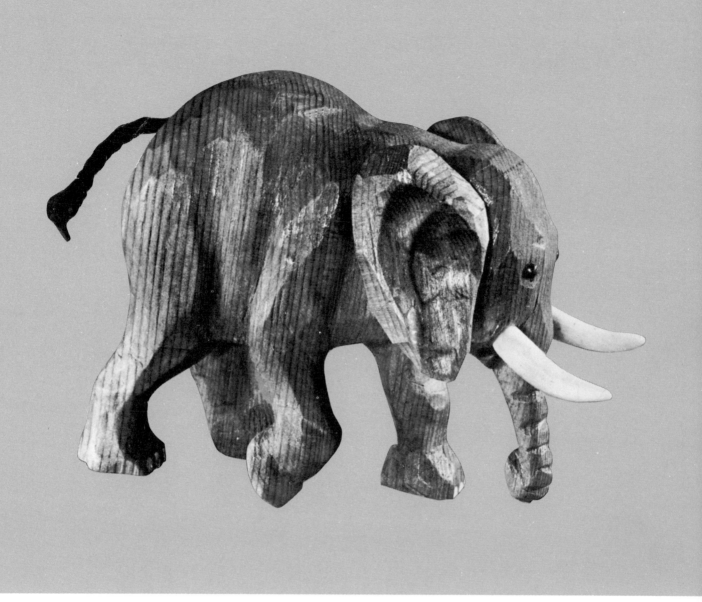

The swinging trunk, the lumbering walk, the big ears, — these are the characteristics of the elephant with which we are familiar.

Carve the figure of two-inch stock, the ears and the tusks of one-fourth inch stock. The figure is redwood, but the tusks are pine. In carving these, considerable pains must be taken not to split off the curved end portion where the grain of the wood runs crosswise. The other ends of the tusks are tapered slightly to be fitted into holes drilled to accommodate them.

The skimpy tail is a short braid of black yarn fitted into a hole in the elephant's rump. Eyes are little round-headed nails.

After finishing the entire figure with shellac, paint the mouth red and the toenails white.

Esmerelda Elephant

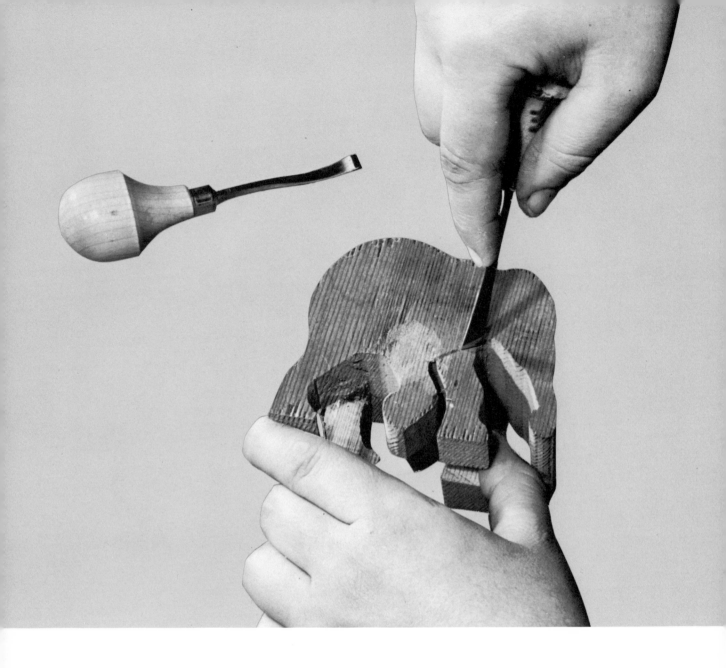

...an extra leg

When the legs of the animal are so placed that it is impossible to remove the surplus leg with a saw, it must be done with a knife or hand chisels. As a first step, make a straight cut across the wood that is to be removed.

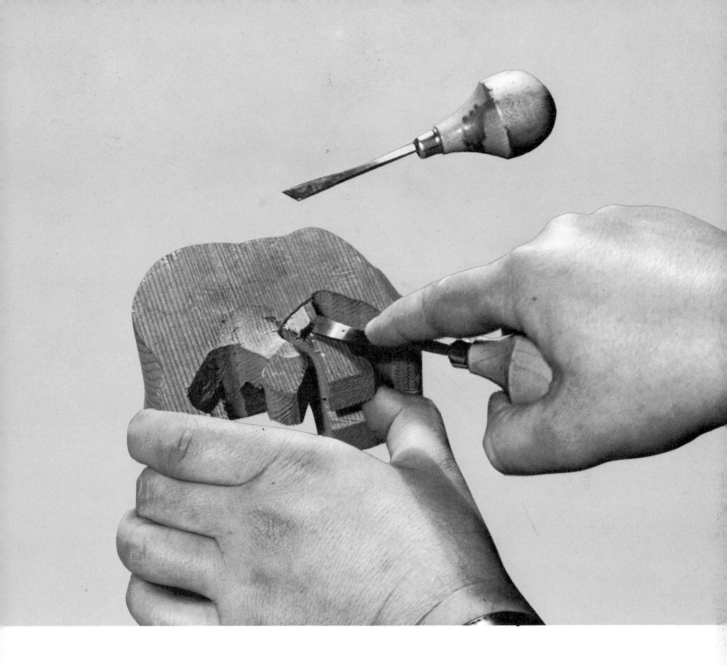

Carve away the wood to the cut. Make a second cut and again remove the extra leg down to the bottom of the cut. Continue in this manner until all the surplus is removed.

...is taken off

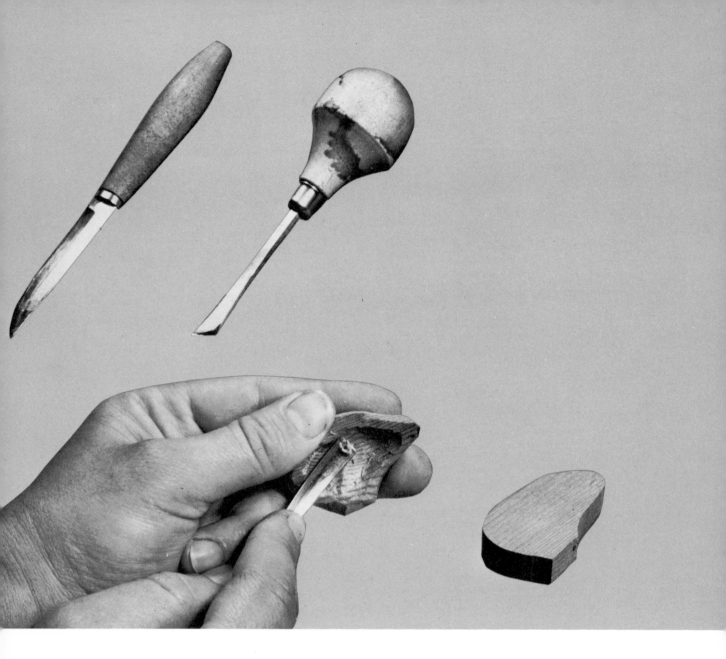

...make the ears

The elephant's ears are carved separately. Hollow out the inside of each ear with a rounded carving chisel. Shape the outside of the ear with scissors. Sand well before gluing to the head.

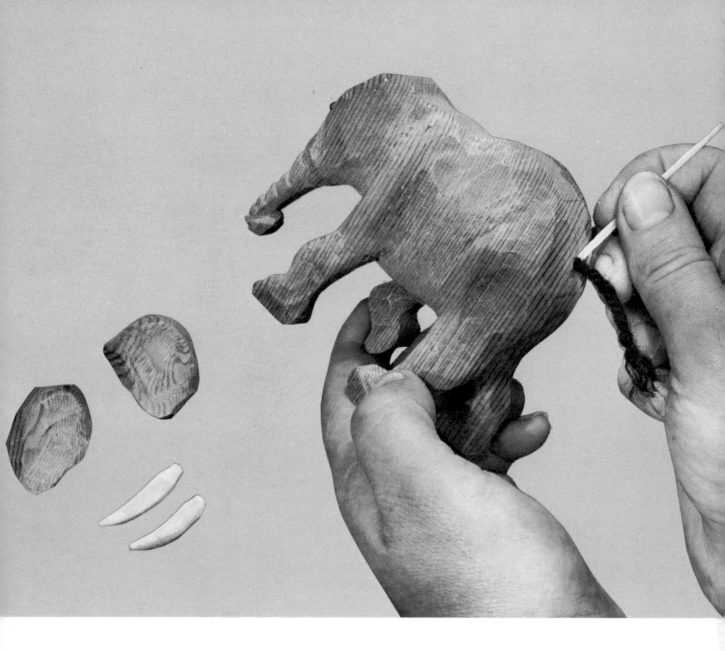

The tail is a short length of black yarn braid. Tie a knot one-half inch from one end. Ravel out the yarn below the knot to make the "brush." Wrap thread tightly around the other end of the braid to keep it from coming unbraided. Drill a small hole in the animal's rump. Fill the hole with glue and tuck in the thread-wrapped end of the braid, using a toothpick to push the braid in place. All of the animals that have yarn braid tails have them attached in a similar manner.

...and tail

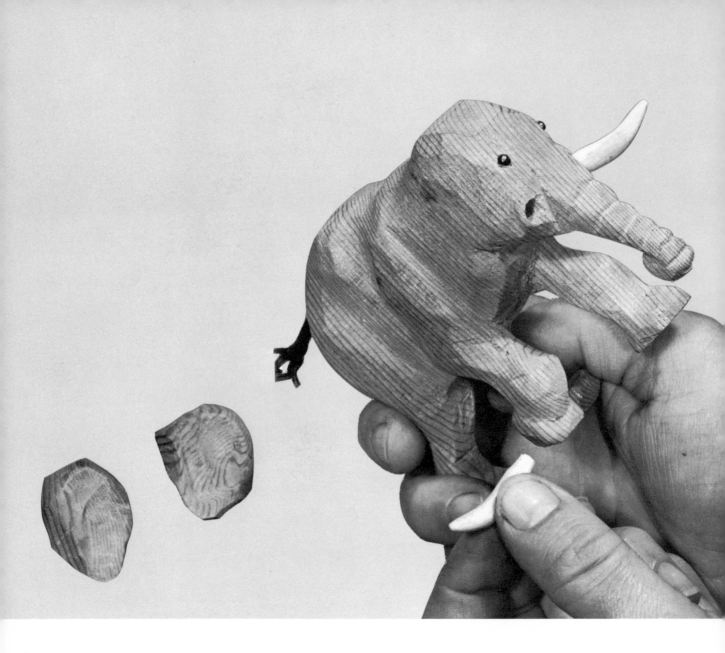

...add the tusks

Carve the tusks from pine. Sand these very smooth to resemble ivory. Taper the butt ends of the tusks a bit. Glue the tapered ends into holes drilled in position on each side of the trunk.

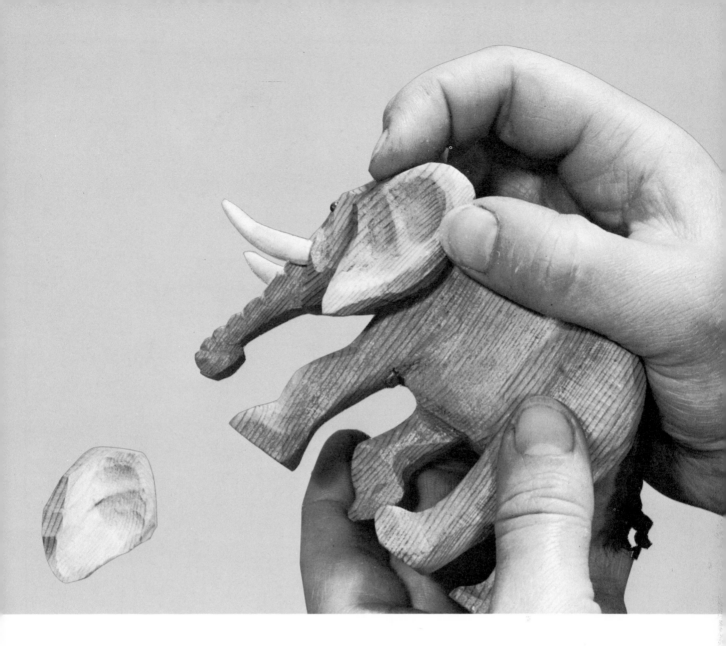

Glue the ears in place to the sides of the head. After assembling
all of the parts, finish with shellac and paint as indicated.

...the ears

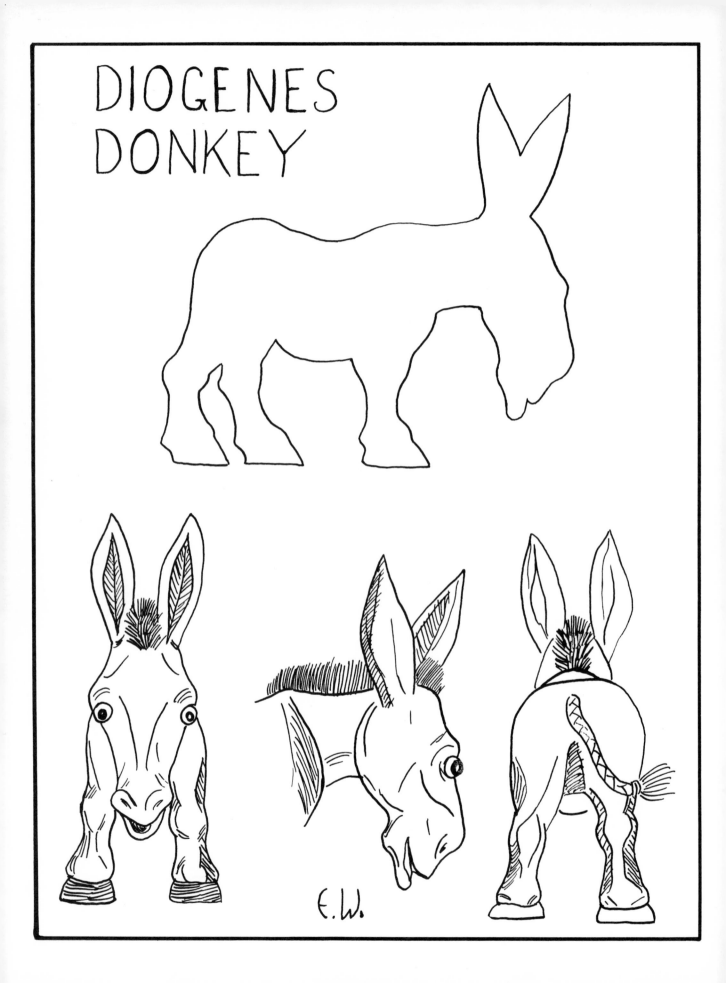

DIOGENES DONKEY

E.W.

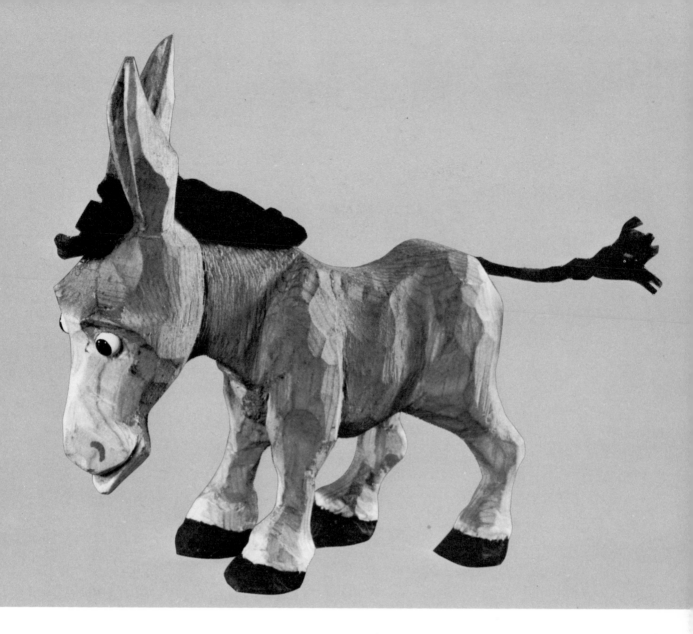

The donkey is carved of two-inch pine stock, with mane and tail of black yarn. Instead of shellac, the finish for this figure is a wash coat of light gray-brown water color. The nostrils and the drooping lip are red, the hoofs black.

Diogenes Donkey

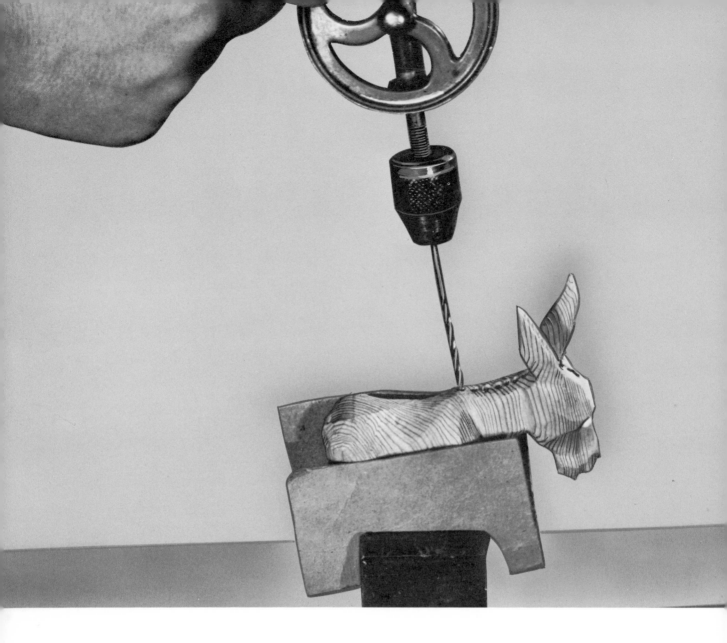

...his mane

After completing the carving, protect the figure and clamp it in a vise. Drill a series of small holes, close together, along the neck.

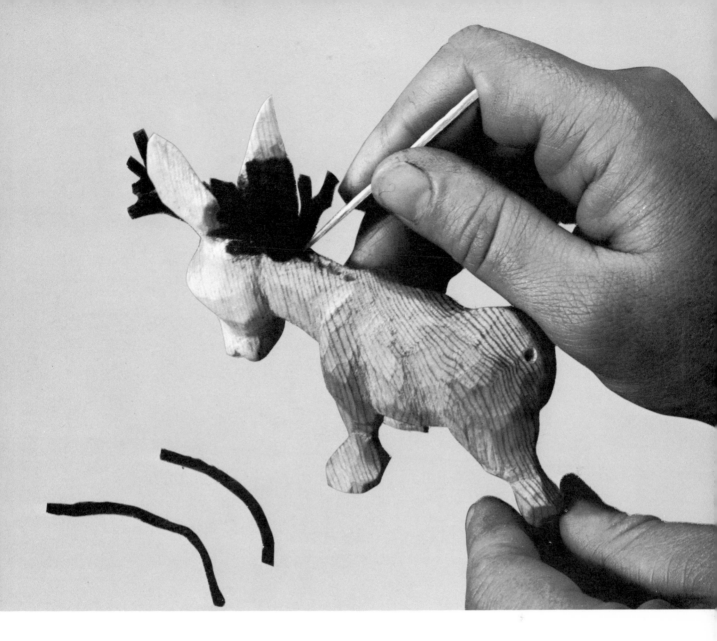

Fill the holes with glue and tuck in short lengths of black yarn. Lay each piece of yarn across the hole so that the center of the piece of yarn is over the hole. Use a toothpick to tuck the yarn down into the glue-filled hole.

...is yarn

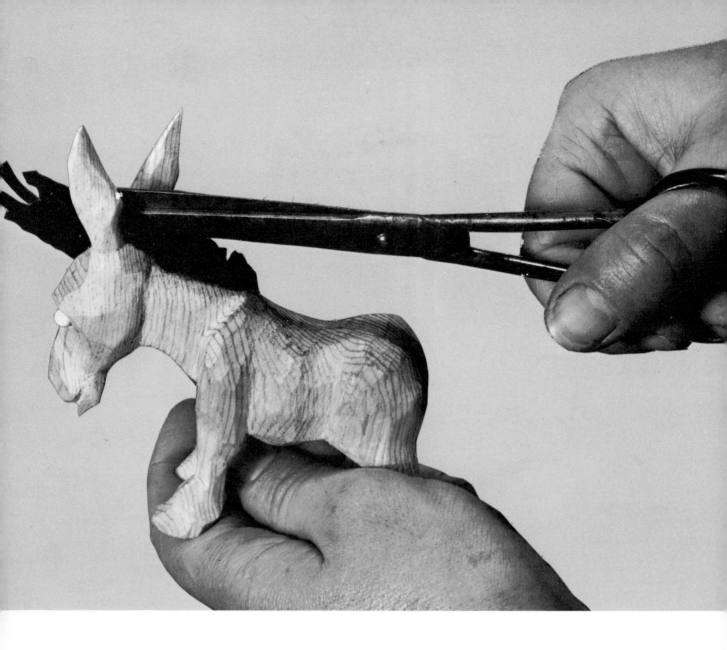

...trim it

After the glue has dried, trim the mane so that it is even and about one-fourth of an inch long.

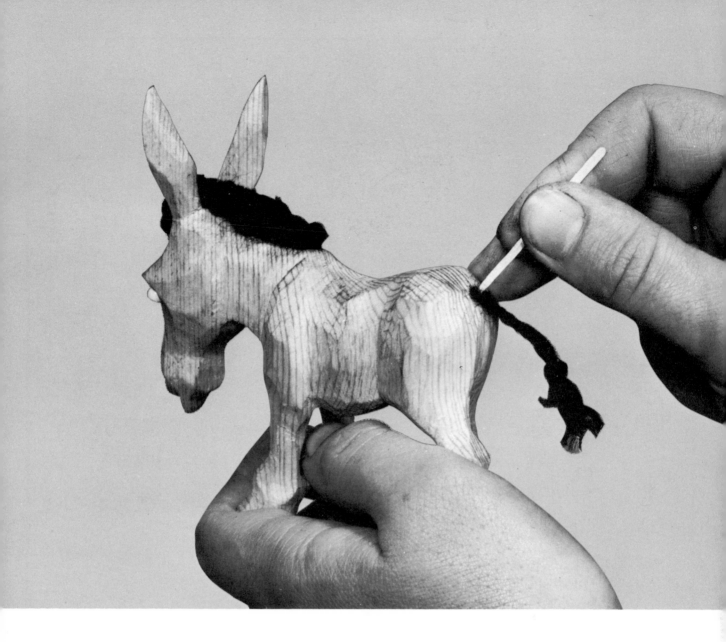

Make a yarn braid tail, as for the elephant, and tuck it into a
glue-filled hole drilled in the donkey's rump.

...add his tail

PANSY PIG

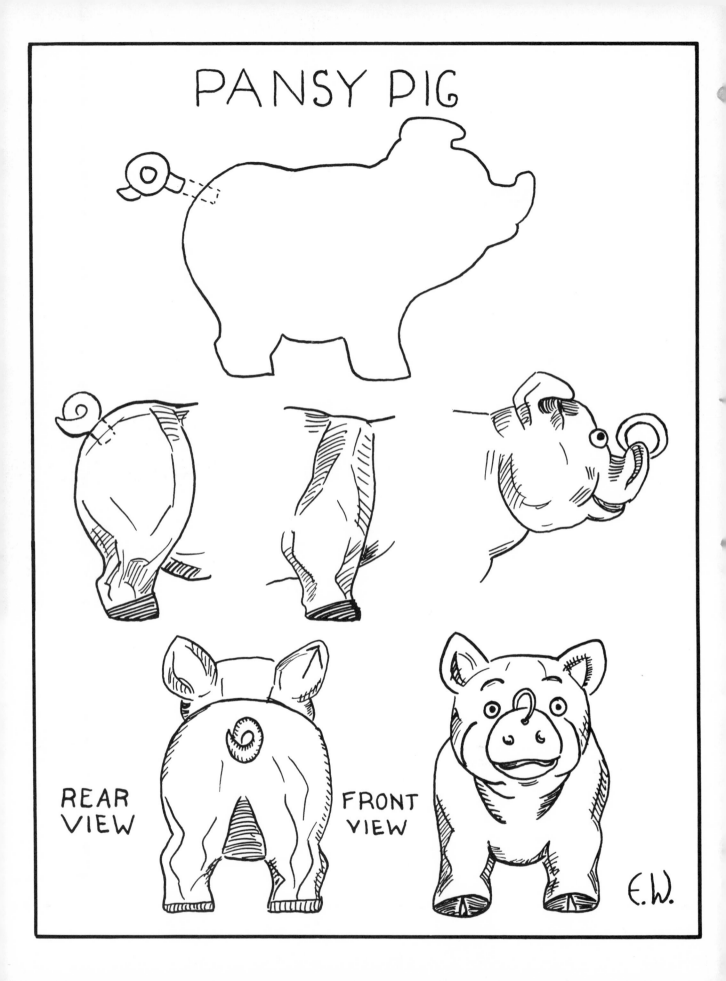

REAR VIEW

FRONT VIEW

E.W.

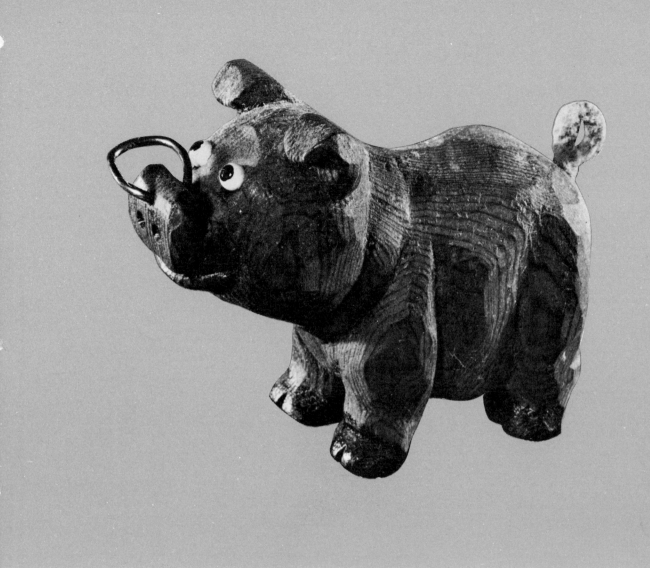

Pansy, our chubby little porker with the ring in the end of her nose, is a roly poly specimen, fat and contented as all pigs should be. The ring is a piece of copper or brass wire, bent to shape around a half-inch dowel. The ends of the ring are slipped into a small hole drilled through her snout, then pressed together with pliers. Pansy's tail is a short length of fuzzy pipe cleaner twisted into a traditional curly pig's tail. Dip the cleaner in brown ink to color it to match the rest of the figure, and glue into a small hole drilled into the pig's body.

Pansy Pig

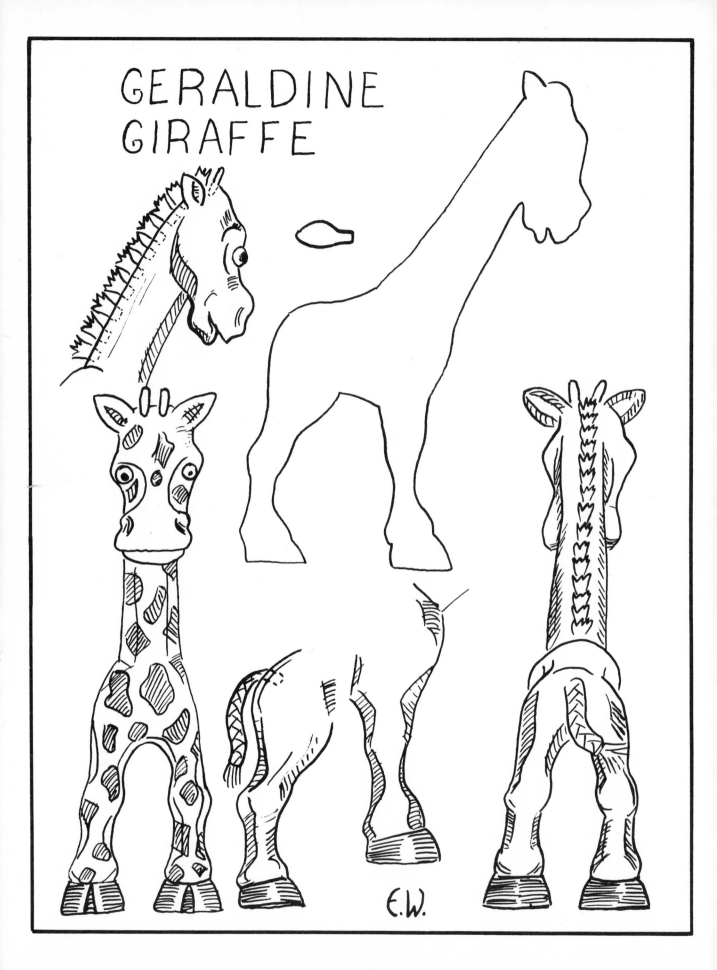

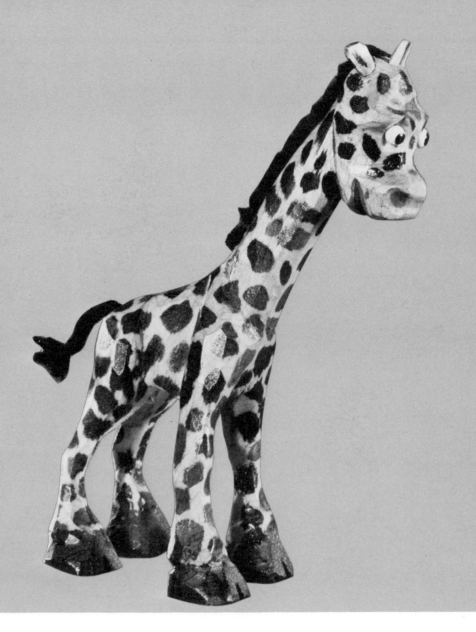

Lay out the pattern for this figure on two-inch pine stock. Ears are carved separately from one-fourth inch pine and glued into holes drilled in the head. The two little horns are short lengths of round toothpicks also glued into holes in the head. Drill a series of small holes down the back of the neckline and glue in tufts of black yarn. Trim the mane even. The tail is a short braid of black yarn glued into a hole drilled in her rump.

After sanding the figure, paint the spots with brown water color, the hoofs black, and the mouth and nostrils red. When the water color is thoroughly dry, give the figure a coat of clear shellac. This gives a traditional yellow with brown spots finish.

Geraldine Giraffe

THEOBOLD TURTLE

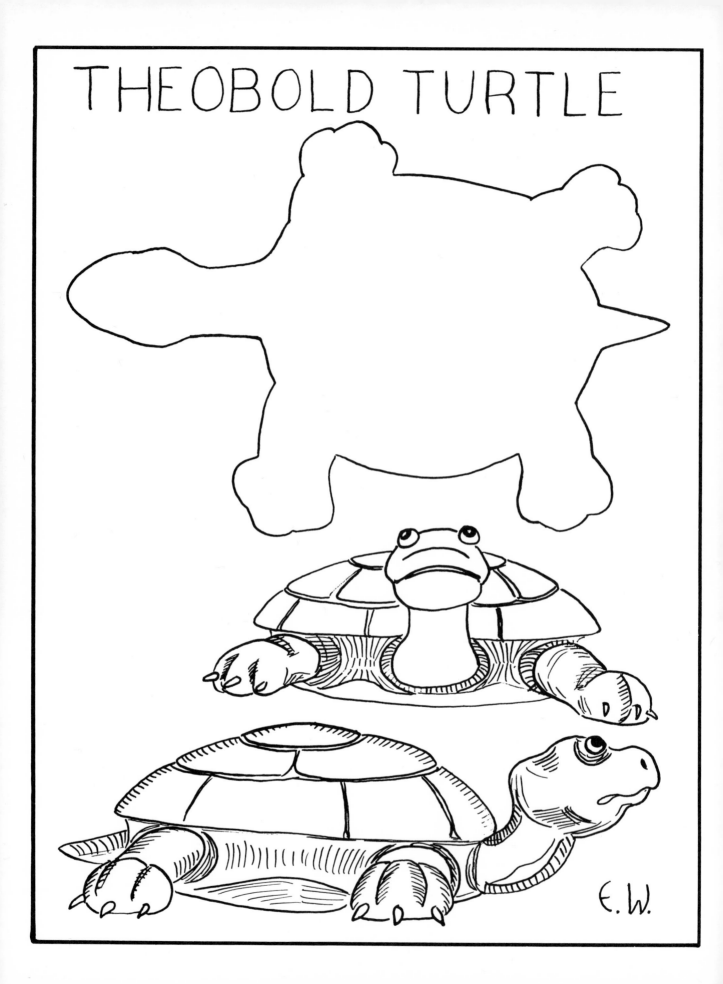

E.W.

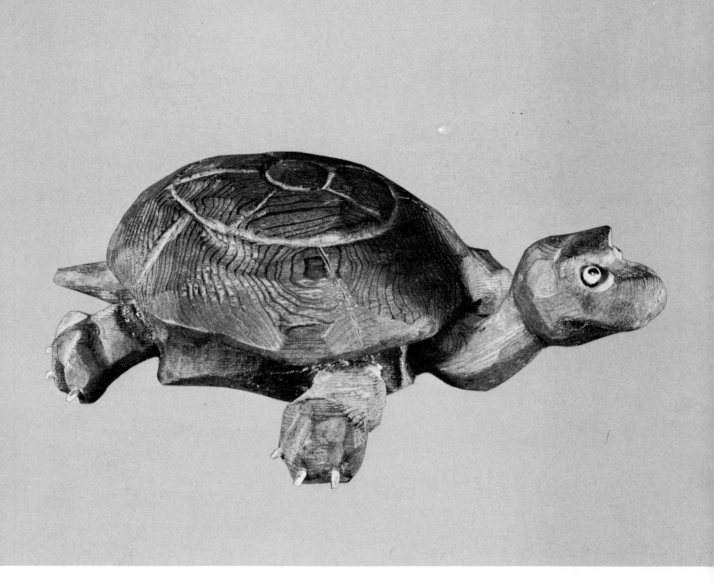

Complete with mossy-backed armor plate, Theobold looks out on the world, ready to withdraw into his "trailer house" in case of rain or other danger.

Lay out the pattern on the flat side of two-inch stock, saw out and proceed with the carving. Shallow knife cuts mark the shell into the traditional turtle shell pattern. Theo's bug eyes are map tacks and his toenails are short sections of round toothpicks glued into holes drilled into the ends of his toes.

To finish, give the figure a coat of walnut oil stain, and rub off. Mix dark green paint with turpentine to a thin consistency and, with a small wad of cloth, dab it onto his back, then rub off leaving just a tinge of green for a "mossy" effect.

Theobold Turtle

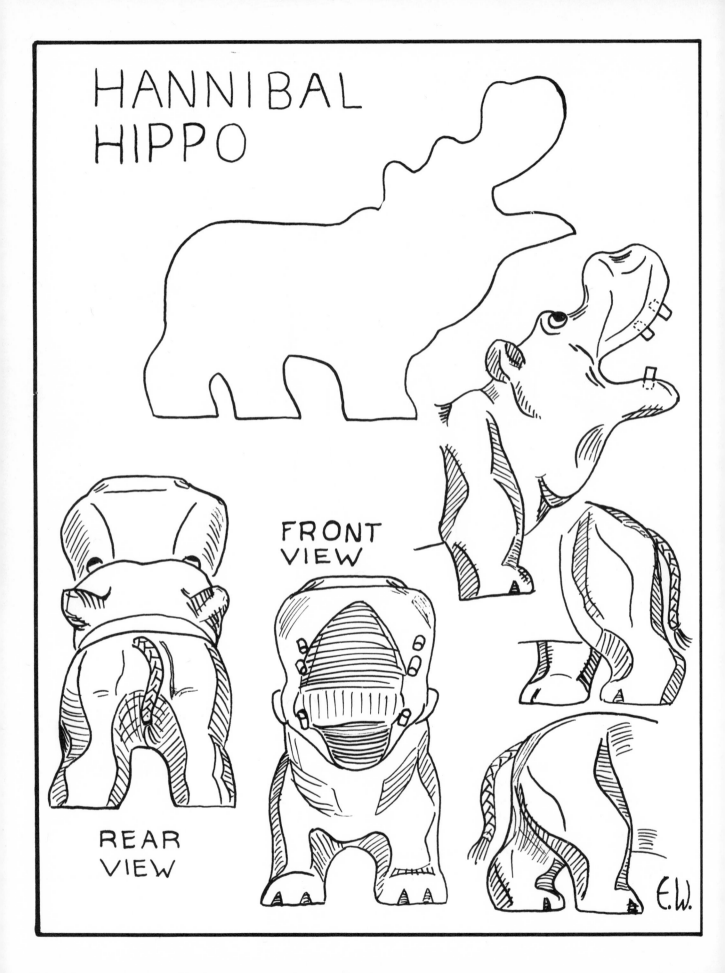

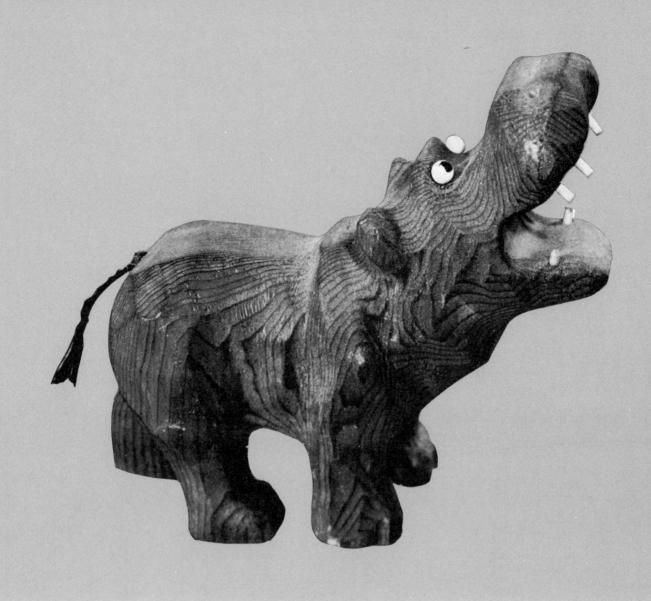

Hannibal is either ready to gobble up a choice morsel, or maybe he is just yawning — who is to say for sure?

This fellow, made of two-inch stock, has a rounded and well-fed appearance. His teeth are short sections of round toothpicks glued into holes in his jaws. Eyes are map tacks with beady black pupils. Paint the inside of the mouth and the nostrils bright red, the teeth white.

The tail is a short braid of black yarn glued into a hole in his rump in the same manner as the elephant.

If made of redwood, the finish is simply a coat of shellac; if of pine, it may be painted gray or light brown.

Hannibal Hippo

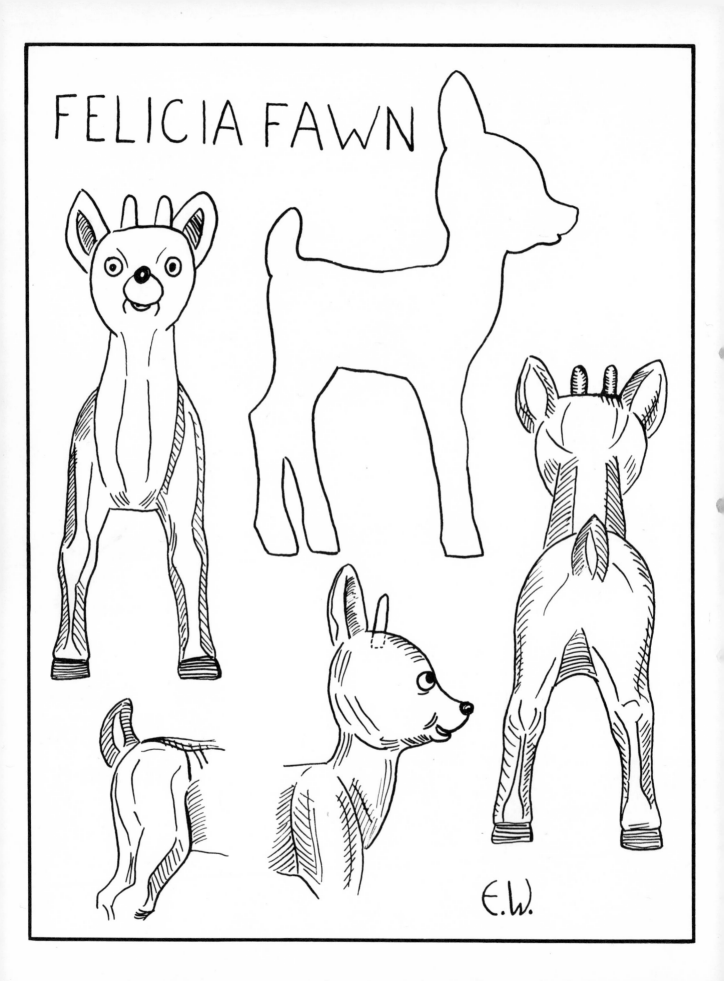

FELICIA FAWN

E.W.

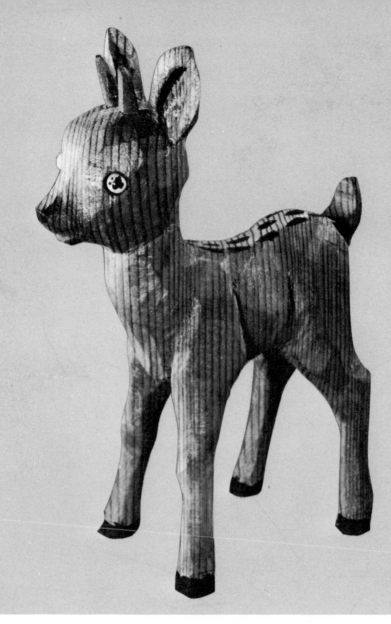

Baby deer are cute and this little fawn with her back spots and little horn bumps is no exception. Redwood is the ideal material for this figure since the color is excellent.

Do the carving in the usual manner, first sawing away one of the back legs on each side as when carving the Gulliver Goat figure. Stumpy horns are sections of round toothpicks glued into holes in the head. Eyes are map tacks with the traditional black pupils. After shellacking the figure, paint the nose black, the mouth red, and the spots on the back brown. The dainty hoofs are shiny black enamel.

Felicia Fawn

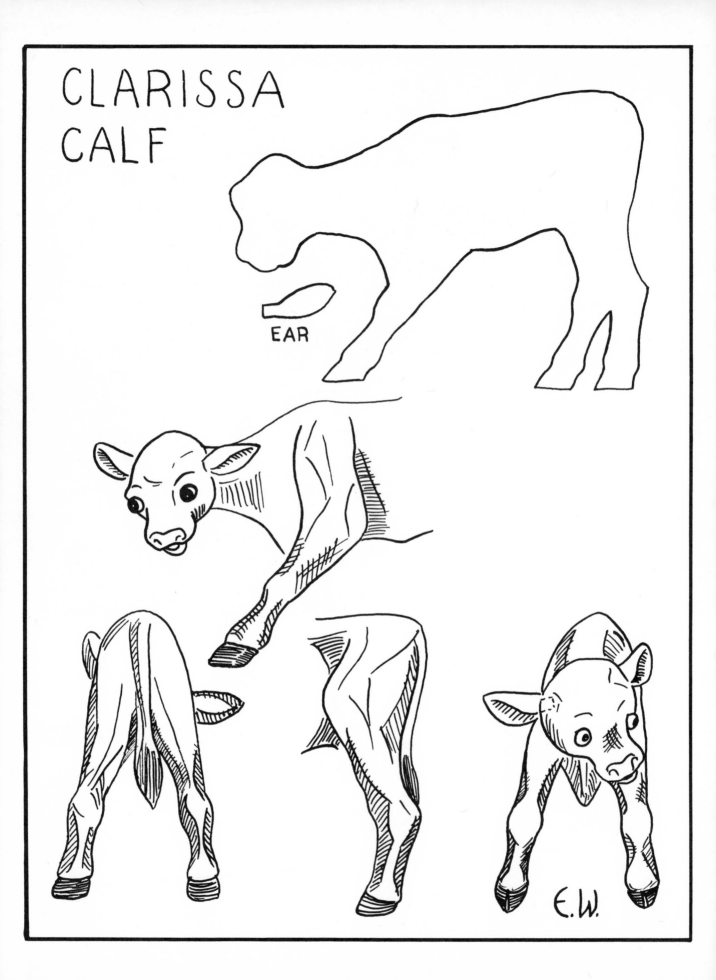

CLARISSA CALF

EAR

E.W.

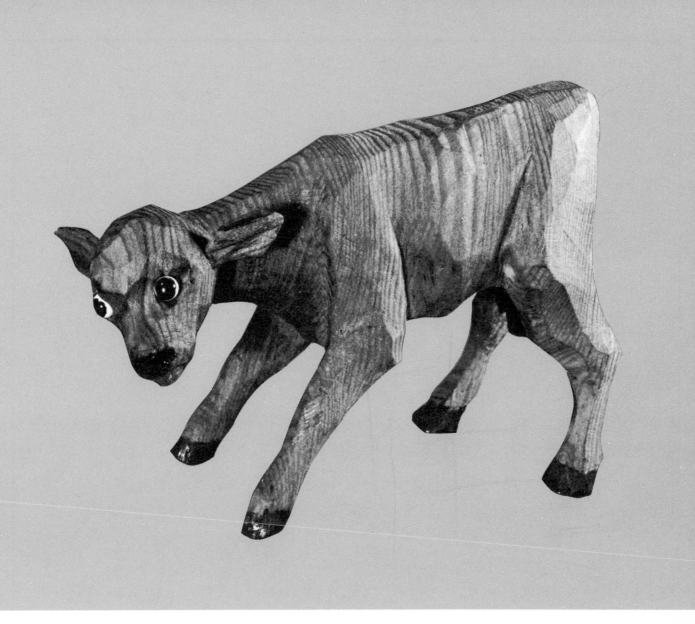

Did you ever try to teach a baby calf to drink from a bucket? It can be as stubborn and balky as a mule and likely you'll end up with more milk on your outside than on the calf's inside. But for all that, they're such innocent creatures.

When carving this figure, note that the head is turned. The angle at which to tilt the head is illustrated in the front view of the drawing.

Carve the ears separately and whittle the ends into peg shapes which are glued into holes bored into the sides of the head.

Clarissa has cloven hoofs, and map tack eyes.

After shellacking the figure, paint the pupils of the eyes, nose, brush of tail and hoofs with black enamel. The mouth is painted red.

Clarissa Calf

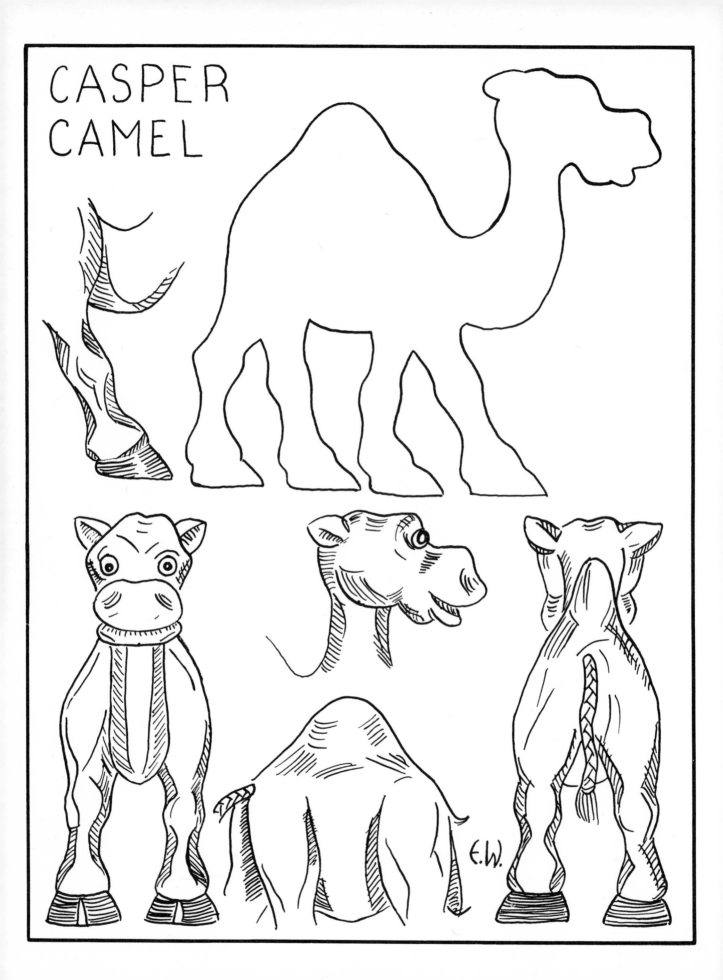

CASPER CAMEL

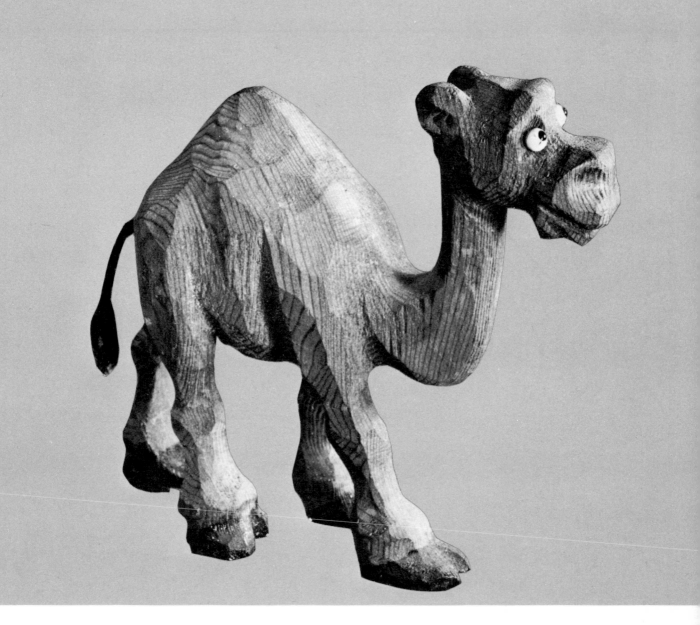

The desert ship looks capable of a journey over the sands and that in good humor.

The figure is carved of two-inch redwood stock (for this animal, as for all others, the choice of wood is optional but the proportions are planned for two-inch stock) and is finished with a coat of shellac. The mouth and nostrils are painted red, the pupils of the eyes and the cloven hoofs are black. The tail is a short braid of black yarn.

Casper Camel

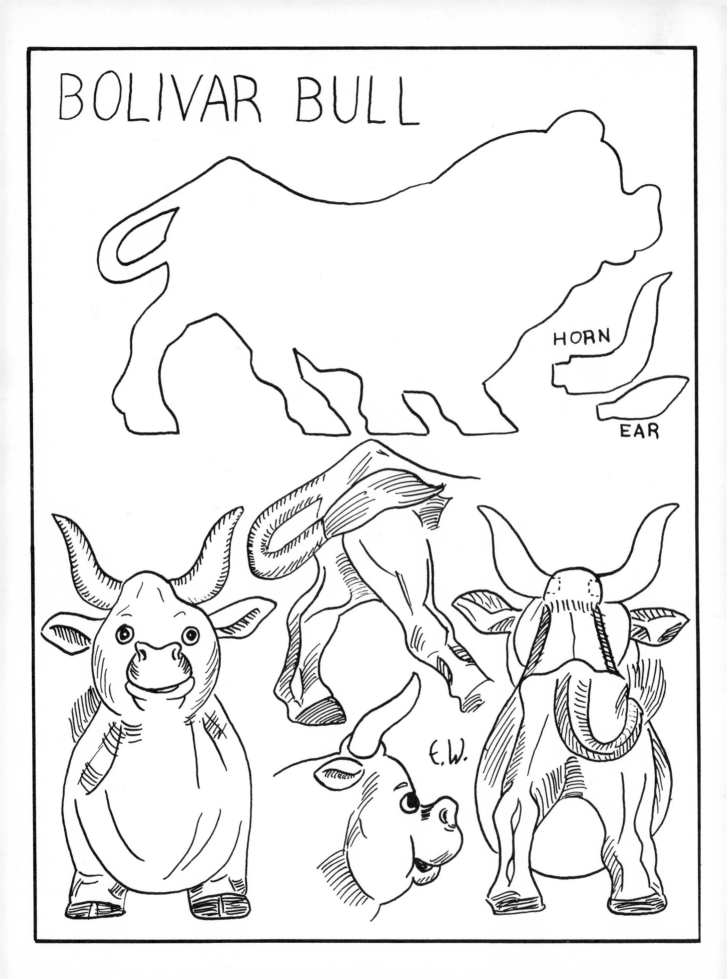

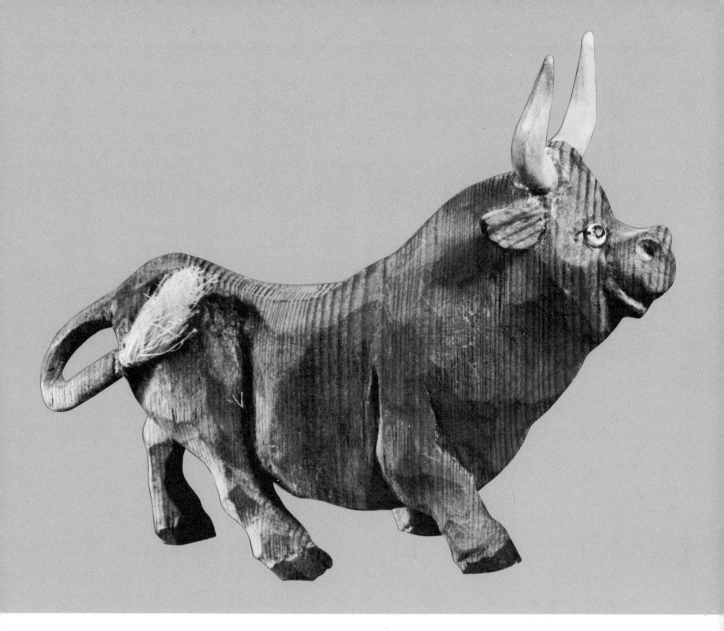

Chesty but amiable and with his tail switching flies, Bolivar steps out to take a walk through the meadow.

The ears and horns of the figure are carved separately, then glued into holes drilled in the head. In carving the tail, note the rear view drawing for detail of the way the tail "switches" against the animal's side. The brush is a short length of hemp wrapping cord that has thread wrapped tightly around one end to hold the strands together. The rest of the length is then raveled out. The thread-wrapped end is glued into a hole drilled in the end of the tail. After the glue has set, the end of the tail is tapered to the point at which the brush is attached.

After the shellac finish the nostrils and mouth are painted red, the eye pupils and the hoofs black.

Bolivar Bull

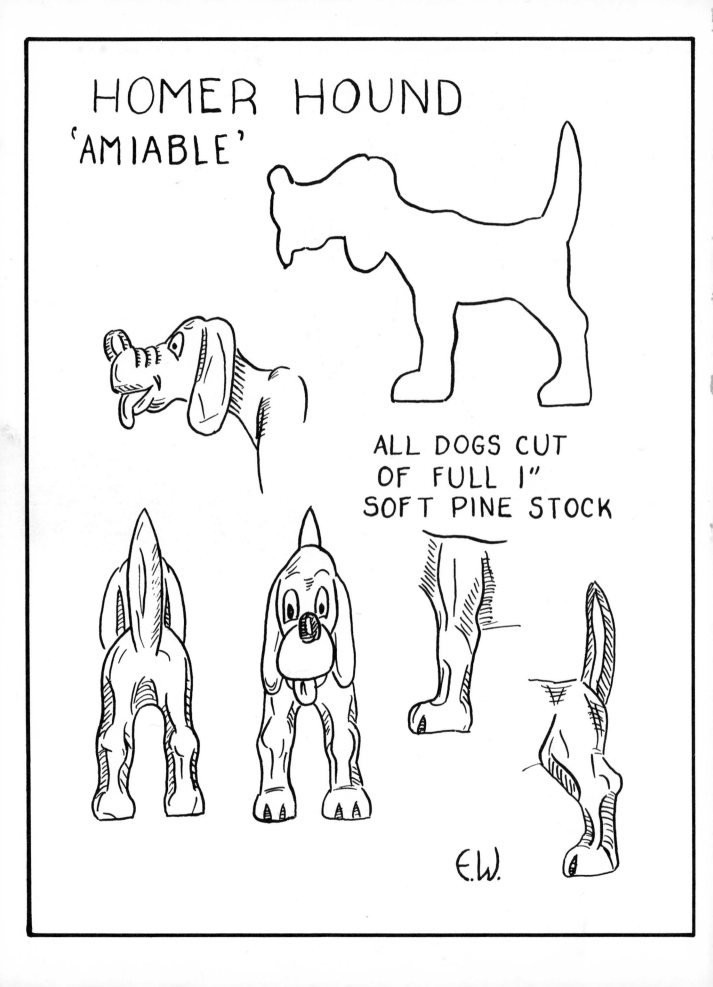

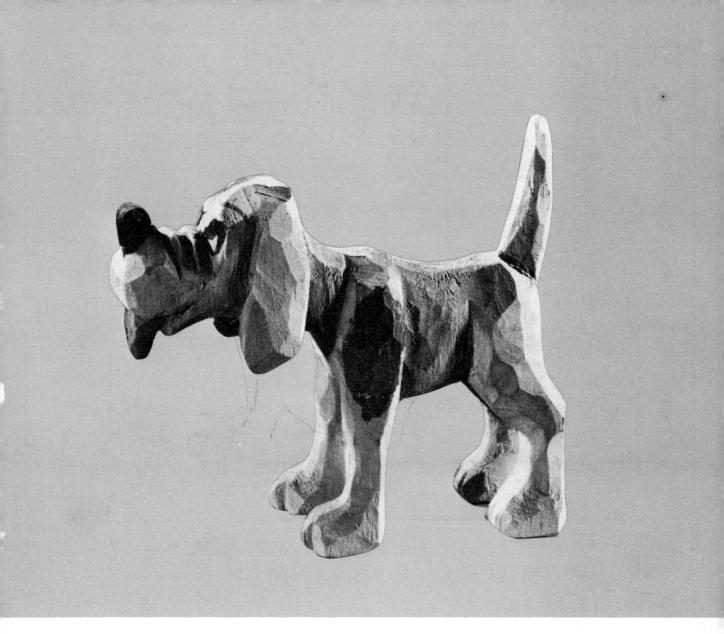

Homer, in this pose and those following, is laid out on full one-inch pine stock, instead of the two-inch stock used for most of the figures. After carving and sanding, he is given a finish of water color. Give an all-over wash of light gray-brown. After this has dried, put on the spots of dark brown. Paint the lolling tongue bright red. The nose is painted jet black. Note that the eyes and eyebrow lines are put in with black paint, using a fine brush. The paint should be quite heavy so there will not be excessive spreading.

Homer Hound "Amiable"

HOMER HOUND
'MOURNFUL'

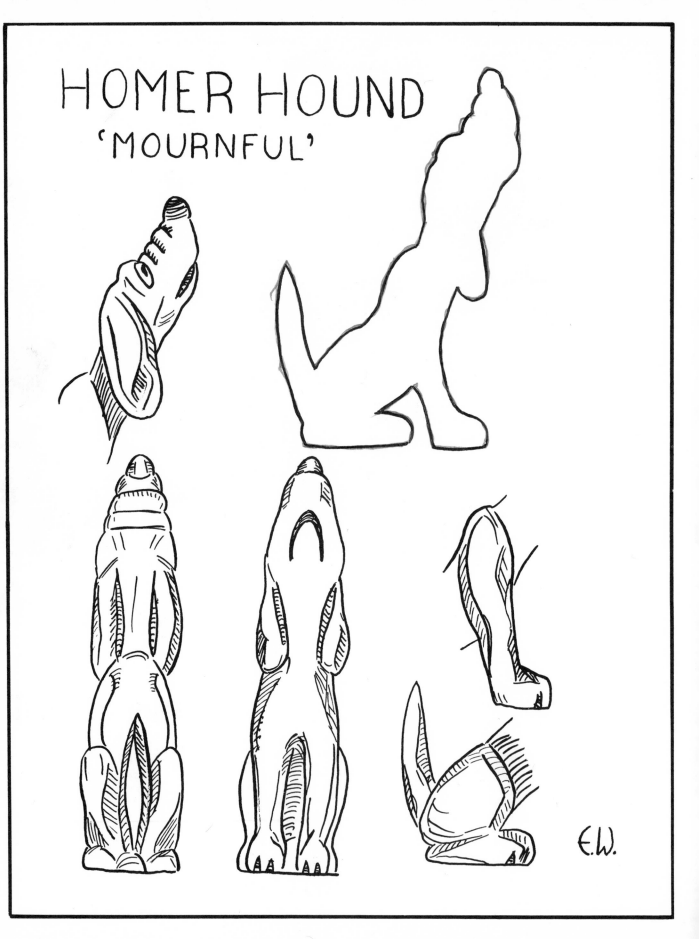

E.W.

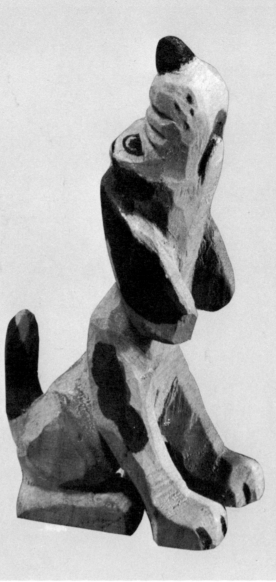

Homer, in a rare mood of melancholy, might be howling at the moon or perhaps in sympathy with some trumpet player's practice scales. Eyes of all of the dog poses are painted instead of the bulging tack eyes which are used for most of the figures. The figure is made of pine, and is painted with water color, light gray-brown with darker brown spots, red mouth, and black nose and eyes.

Homer Hound "Mournful"

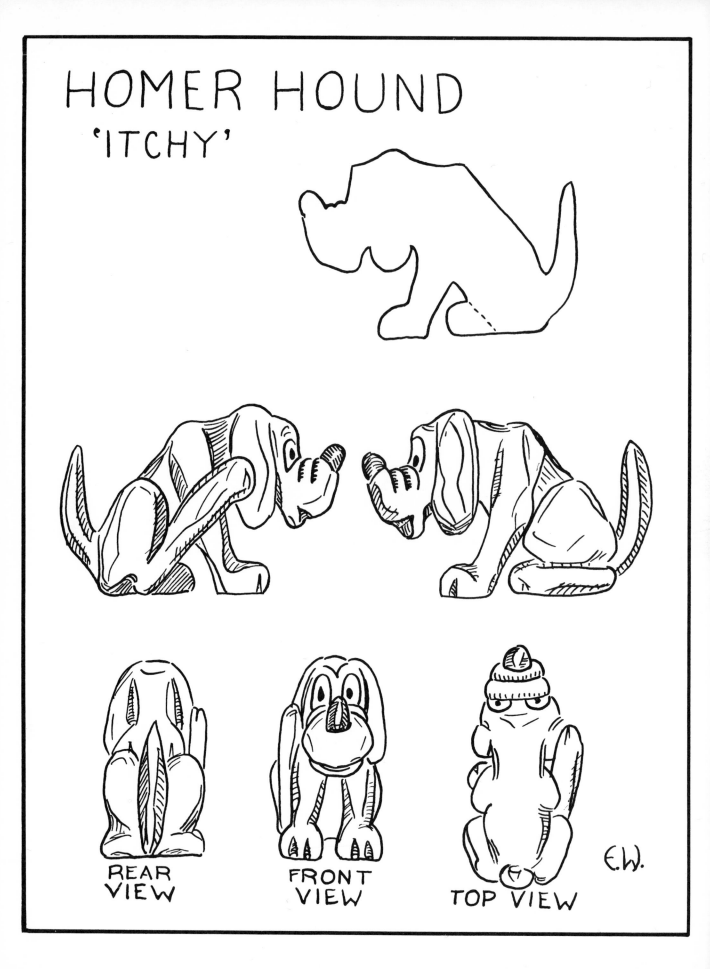

HOMER HOUND
'ITCHY'

REAR VIEW

FRONT VIEW

TOP VIEW

E.W.

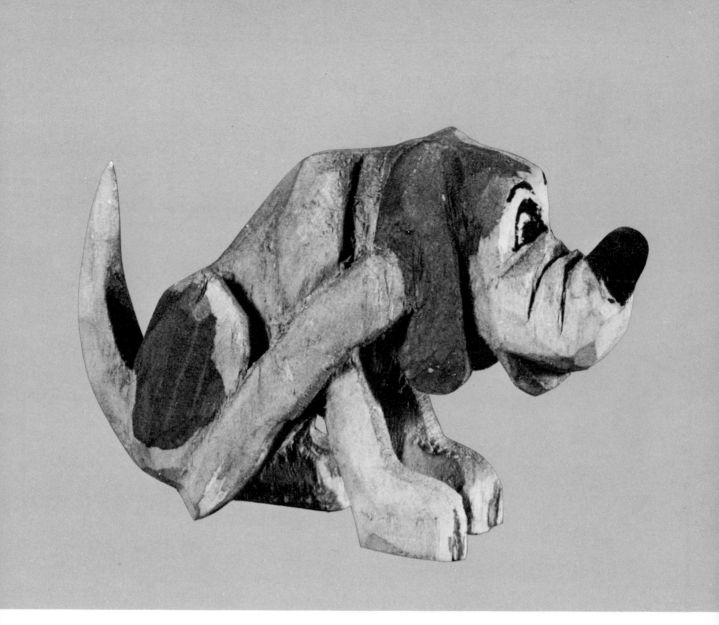

Homer here is a candidate for a flea soap company experiment station. After sawing out this figure, saw off the right leg at the point indicated by the dotted line in the pattern drawing. The expression of the eyes and the droop of the mouth help to give character to this pose.

Homer Hound "Itchy"

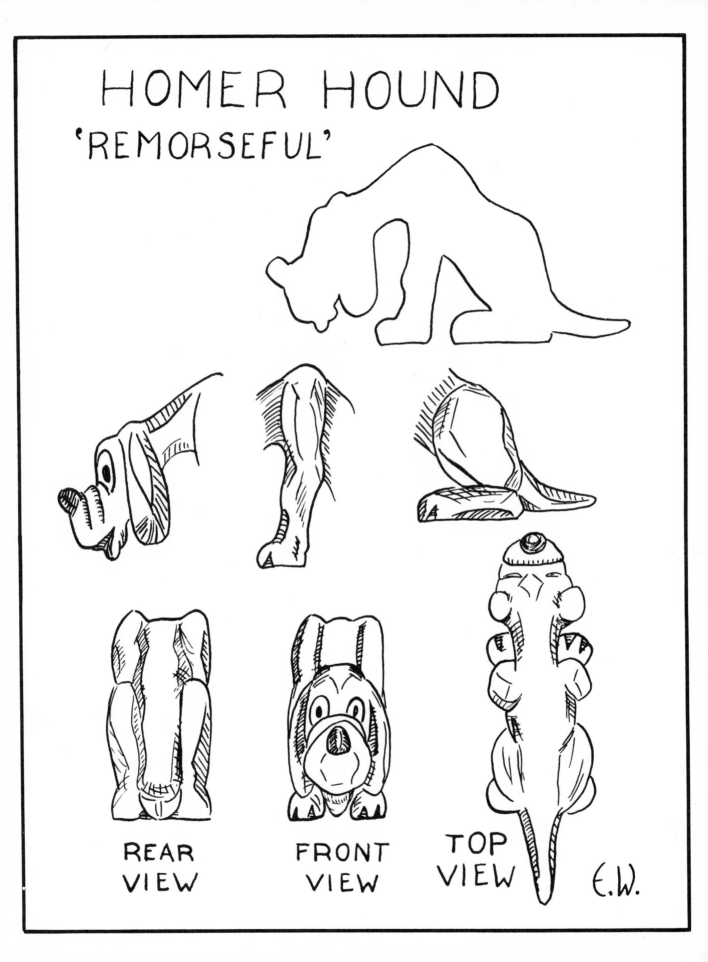

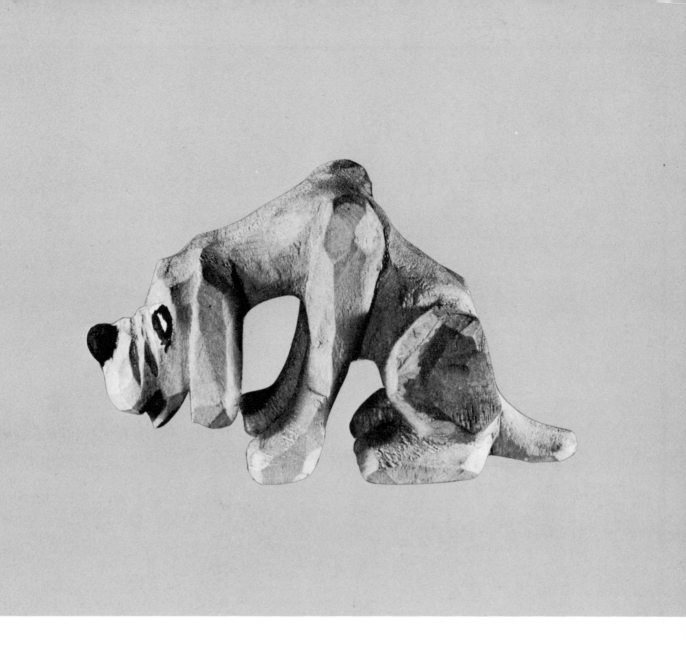

Sad is the pup who has suffered his master's rebuke, whether it be for digging up the flower bed to bury a choice bone or for chasing the neighbor's cat.

Mood is captured here by the hunched shoulders, the hanging head and the drooping tail. In carving the tail, care must be exercised because with the grain of the wood running crosswise, it is easy to split off the entire tail. Should this happen, it will probably be a clean break that may be fitted accurately back into place and secured with glue, so it will hardly be noticeable when dry.

Homer Hound "Remorseful"

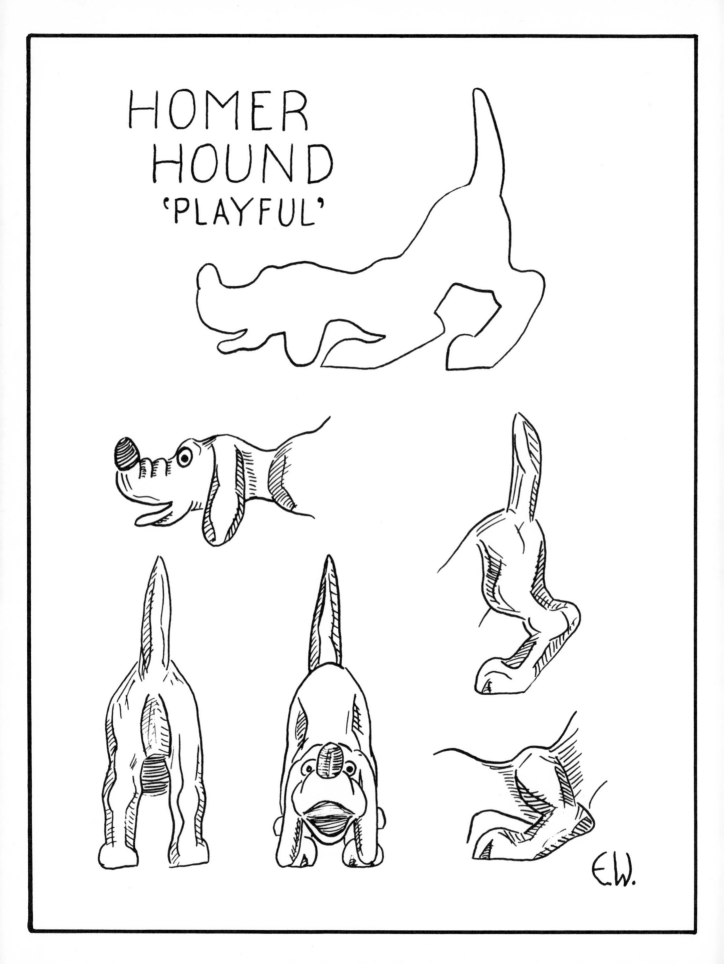

HOMER
HOUND
'PLAYFUL'

E.W.

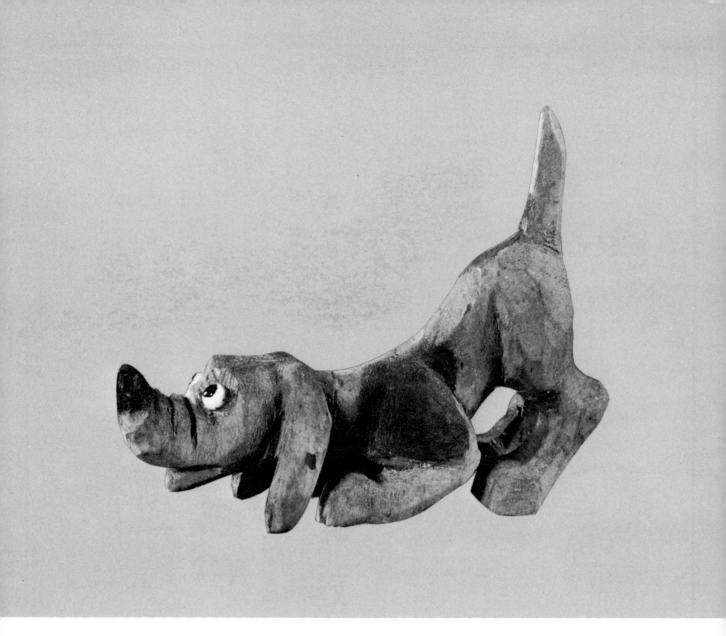

Ready to leap for a ball tossed to him, or chase a stick, Homer begs to be played with.

This figure is carved and painted in a manner similar to the other dog poses. One difference in this figure is in the eyes. For this one, map tacks with painted pupils have been fitted into eye sockets, as in several of the other figures in the book.

Homer Hound "Playful"

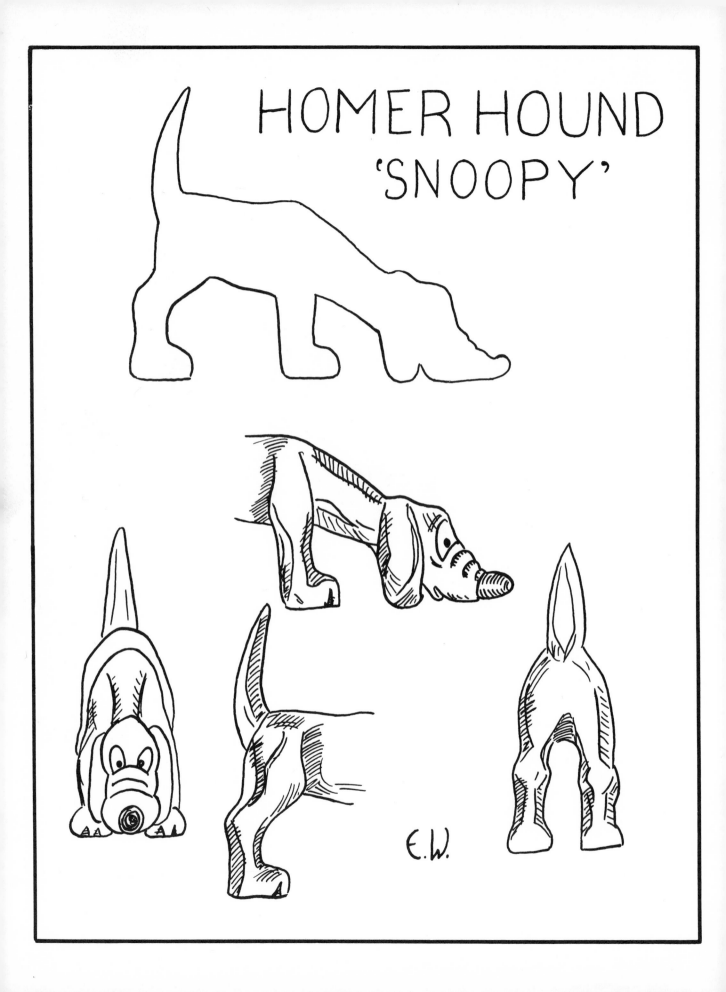

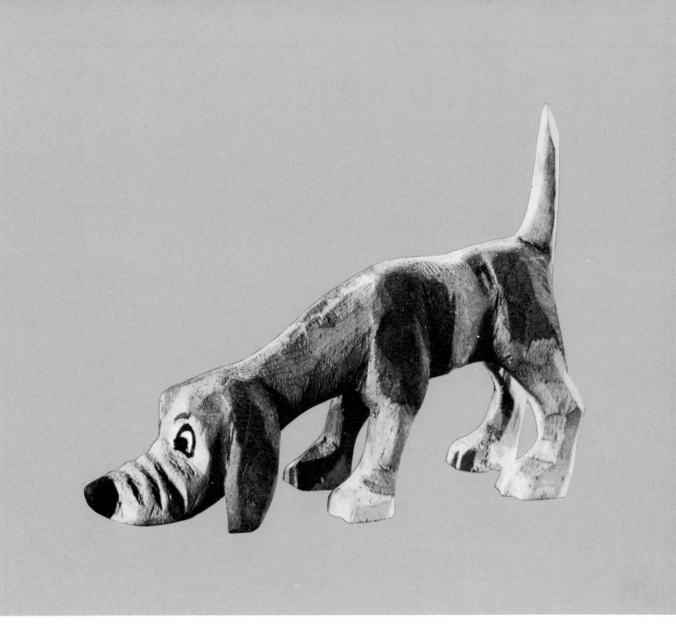

Somewhere, on one of the branches of Homer's family tree, there must have been a bloodhound. At any rate, he is ready and eager to pick up the scent — even though it may be that of a long buried and all-but-forgotten ham bone.

Long nose to the ground and floppy ears dragging help to give Homer the "sniffing" pose.

Homer Hound "Snoopy"

DMITRI DINOSAUR

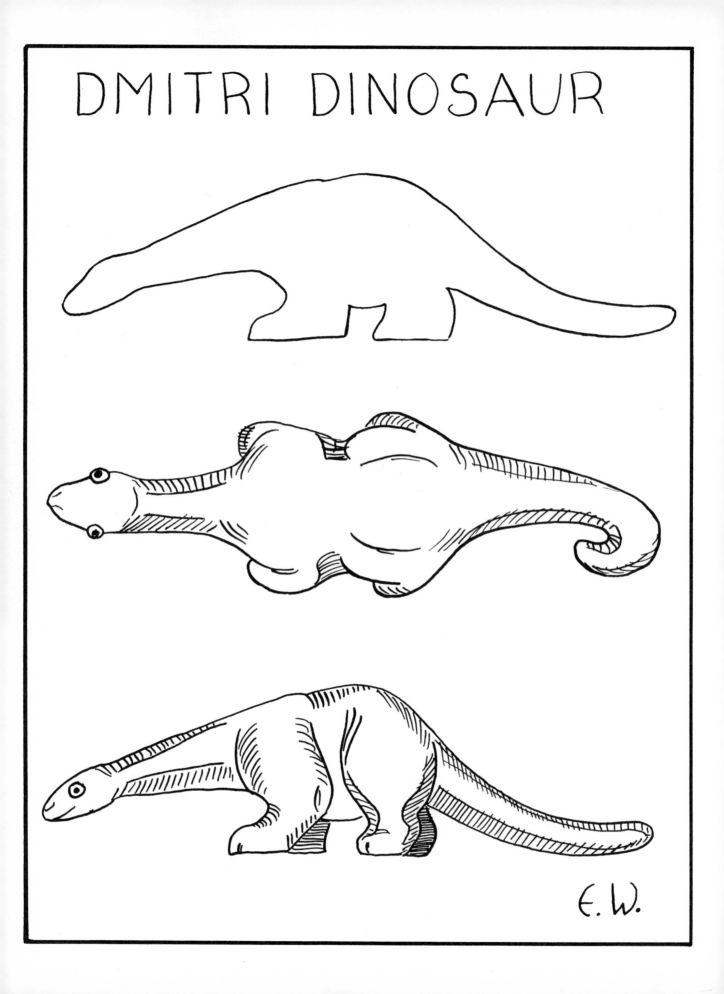

E.W.

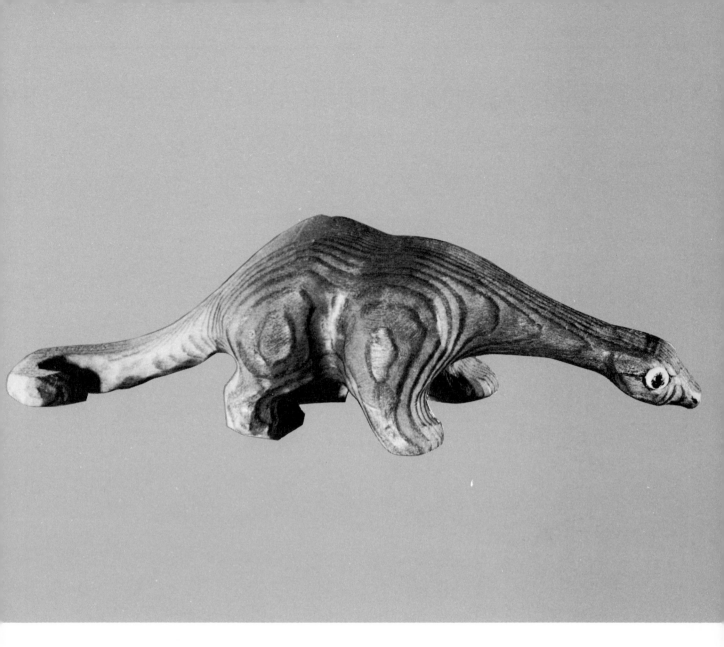

The group of giant lizards and other prehistoric creatures that are commonly known as dinosaurs and which once roamed our land are "naturals" for caricature carving. Each one has some outstanding characteristic, and when reproduced in miniature, the animals are highly entertaining, though one would have viewed them with an entirely different attitude had we had a chance to meet them face to face.

The dinosaur was reputed to have his brain in the end of his tail, and from his simple-minded appearance, it is not too hard to give credit to this rumor.

In contrast to most of the other figures, this one is well sanded to give a rounded rather than an angular appearance. Fit the recessed eye sockets with white map-tack eyes and paint the pupils with black enamel. After shellacking the figure, mark the nostrils and mouth with black India ink.

Dmitri Dinosaur

SAMMY STEGOSAURUS

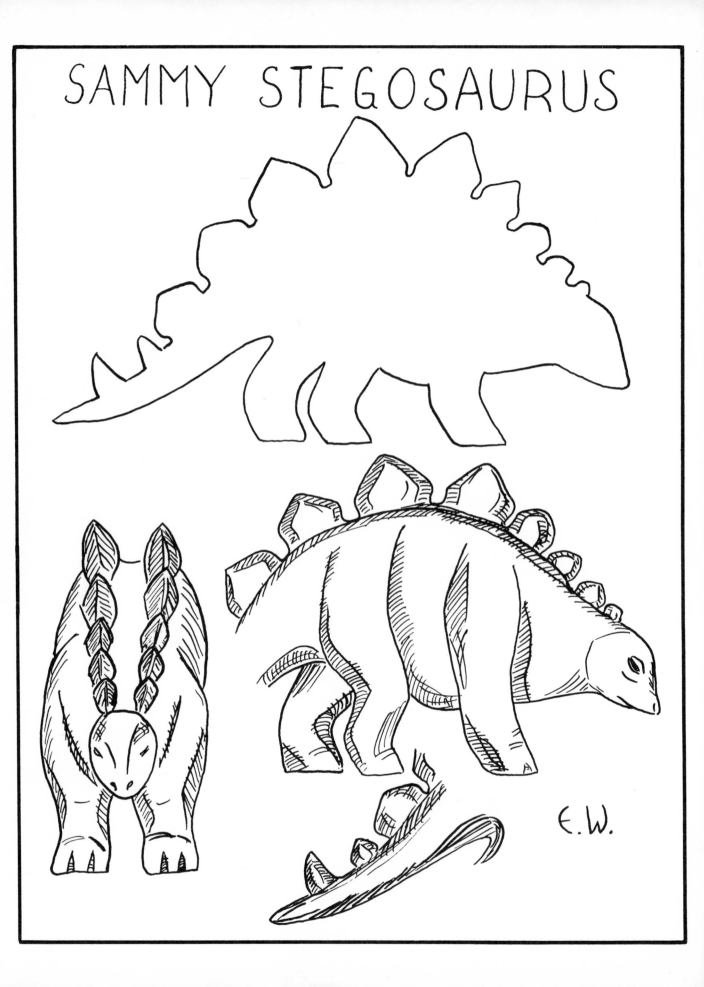

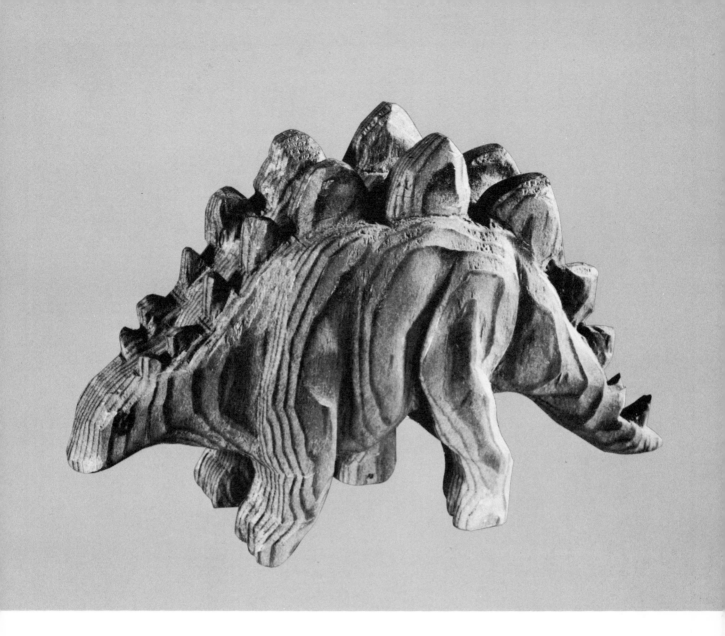

Another of the creatures of the early days was the stegosaurus. He was identified by the two rows of spines running along his back and ending in a horny projection on the end of the tail.

Two-inch stock is used for Sammy. In carving the two rows of spines, take care not to split them off, especially the smaller spines and the tail horn. Since the grain runs crosswise on some of them, they will break off if too much pressure is put on them.

On this animal, the eyes, nostrils and mouth are marked in India ink after the figure has been shellacked.

Sammy Stegosaurus

TILLIE TRICERATOPS

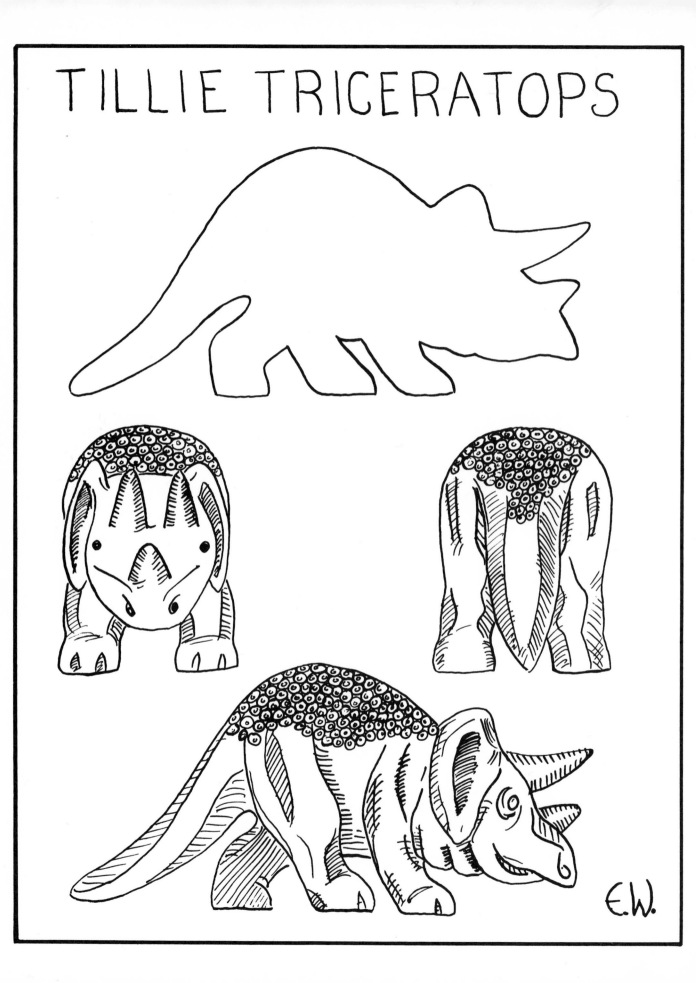

E.W.

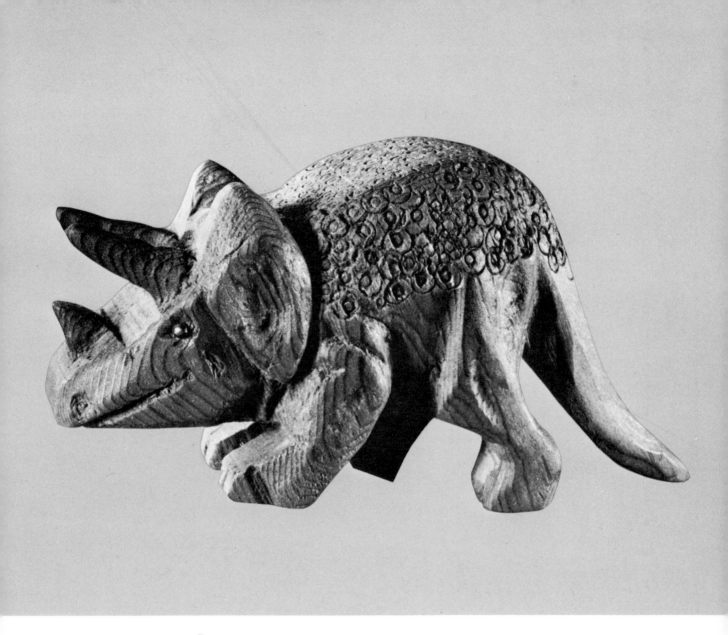

The three-horned prehistoric, like most of the others of that time, is reputed to have had a ridiculously small brain. The hide had a "coat of mail" appearance.

In carving this animal, note that the hide has a wrinkled and baggy appearance, especially around the eyes and jawline. For the eyes, use small round-headed steel tacks, and after carving and sanding, use a hand leather punch and nail set to give the "mail" appearance to the animal's back.

Tillie Triceratops

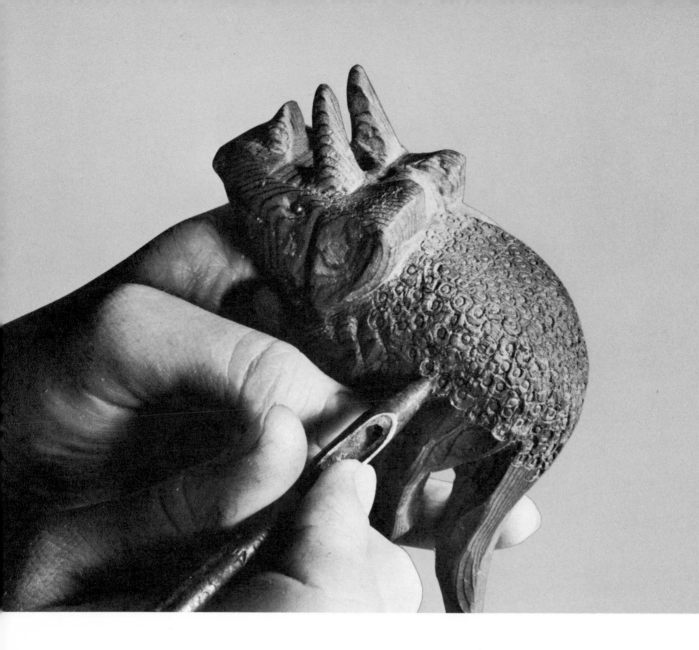

...her hide

As a first step in making the textured hide on the back of the triceratops, use a hand leather punch. Hold the sharp point of the punch against the wood and press, at the same time using a twisting motion to make a ring shaped mark on the wood.

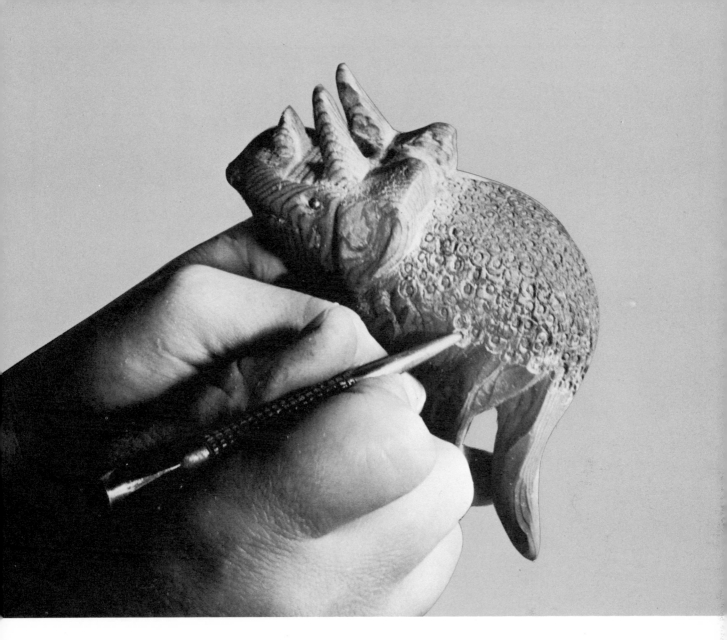

The second step in texturing the hide is to use a small nail set to make a second smaller ring impression inside each of the larger ones. The nail set, like the punch, is pressed and twisted against the wood to make the impression. The entire back is covered with this texture design.

...is rough

SOPHRONIA SAIL REPTILE

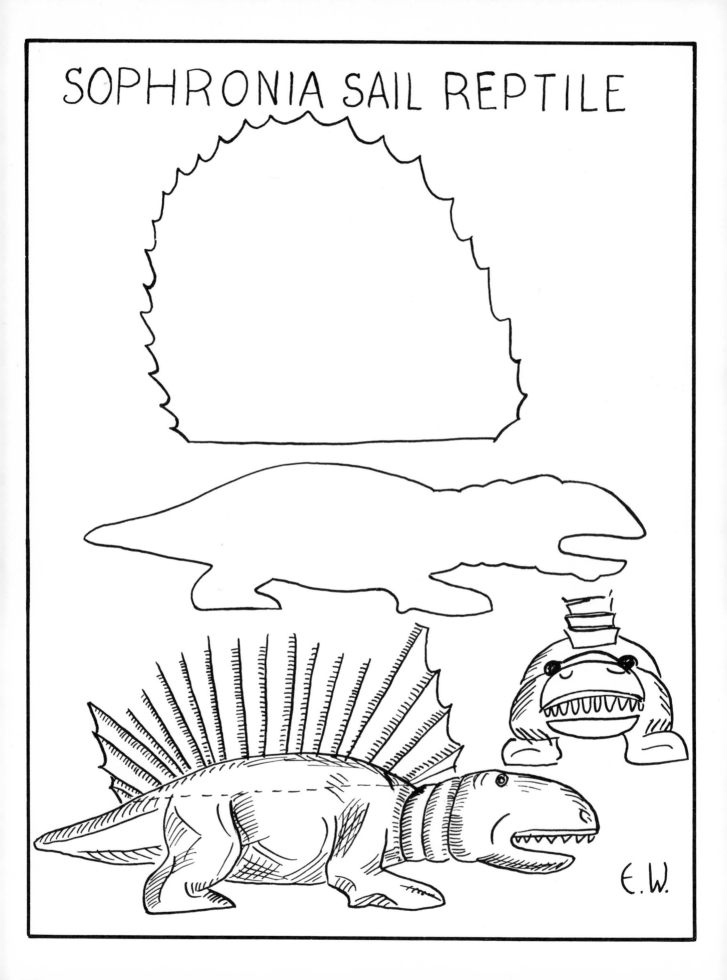

E.W.

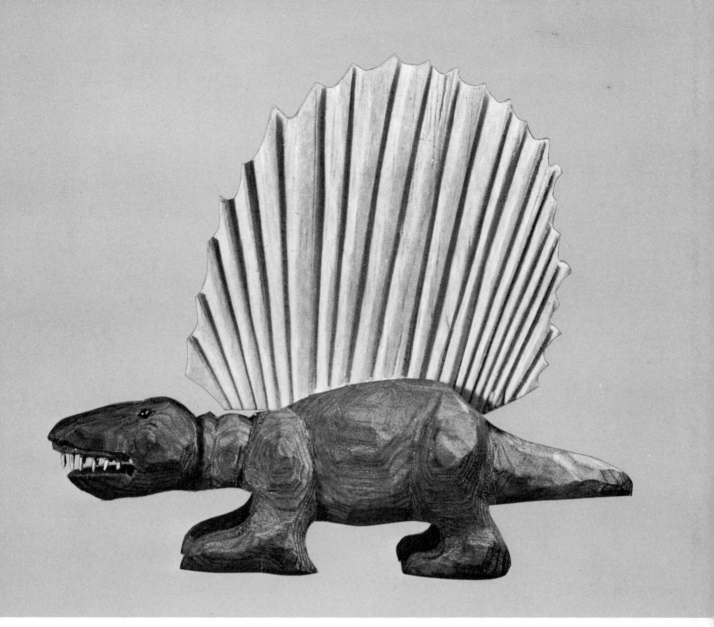

One of the giant lizards among the prehistoric group, was the sail reptile. It was aptly named for it had a tall sail on its back.

Carve the animal figure from redwood (or other two-inch stock). Along the top of the back, make a groove one-half inch wide, into which the sail will be fitted.

Carve the sail from one-half inch pine stock and glue into the recess. Fit an "upper plate" into the mouth. This is made of cardboard with round toothpick teeth, as explained in the following photographs. For the eyes, use small steel-headed tacks or brass escutcheon pins. A coat of shellac on both the redwood figure and the light colored sail is the finish used.

Sophronia Sail Reptile

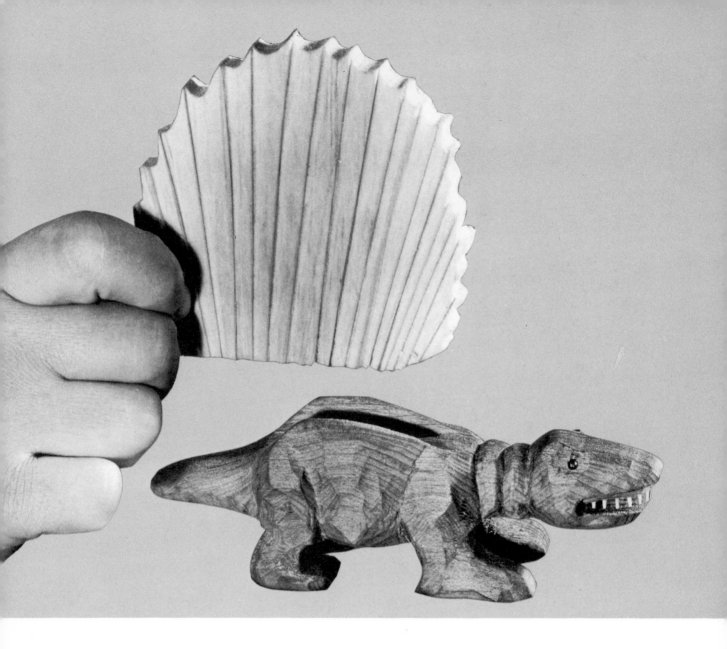

...her sail

Carve the sail from one-half inch pine stock. Glue this into the recess cut along the top of the back.

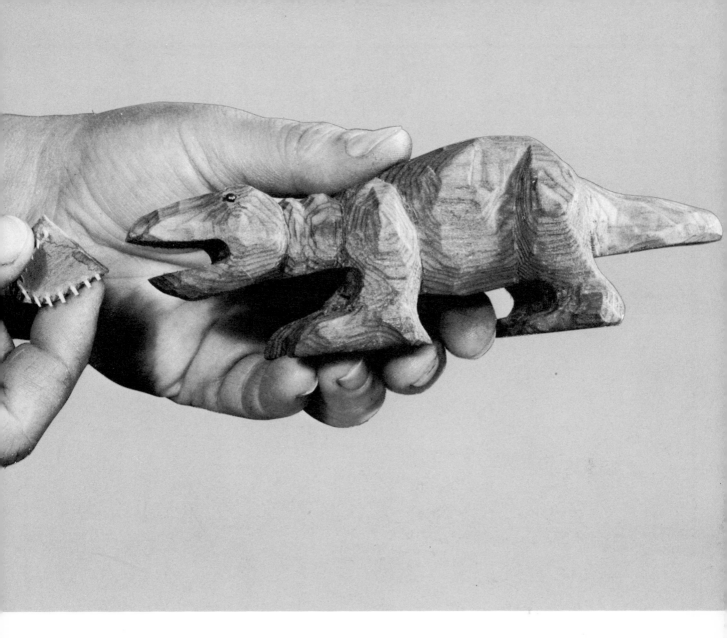

Make a cardboard "upper plate" to fit inside the roof of the mouth. Cardboard from the back of a pencil tablet or shoe box is about the right weight. Paint this red with water color. Around the edge, make a series of small holes with the point of an ice pick or a sharp finishing nail. Through these holes, push the "teeth" which are short sections from the pointed ends of round toothpicks. Glue the plate inside the mouth.

...and teeth

TEDDY TYRANNOSAURUS

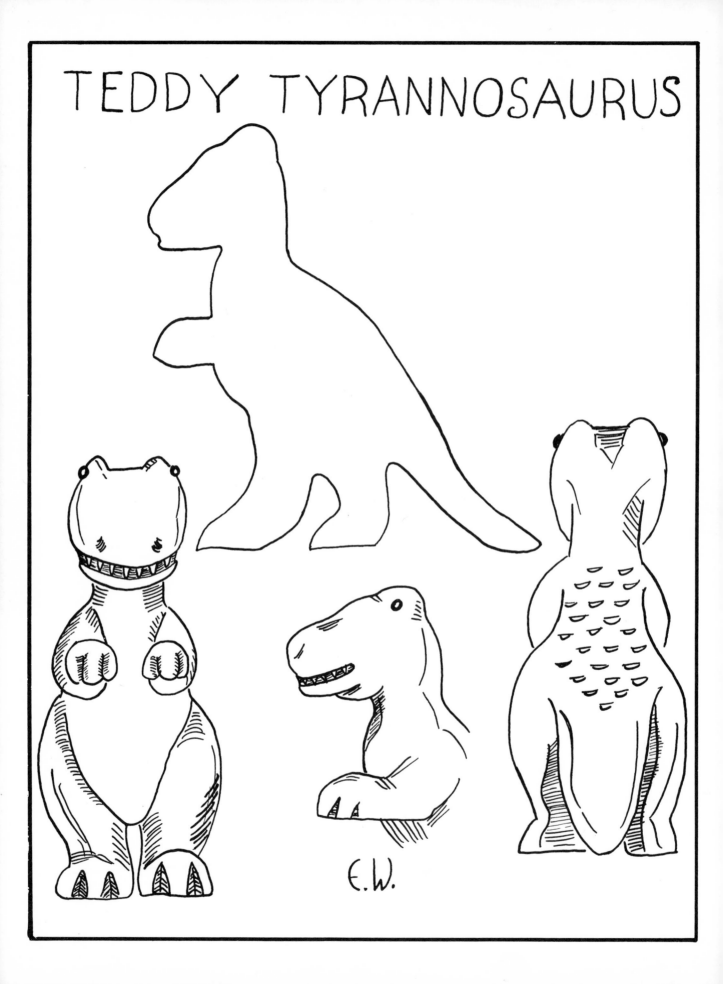

E.W.

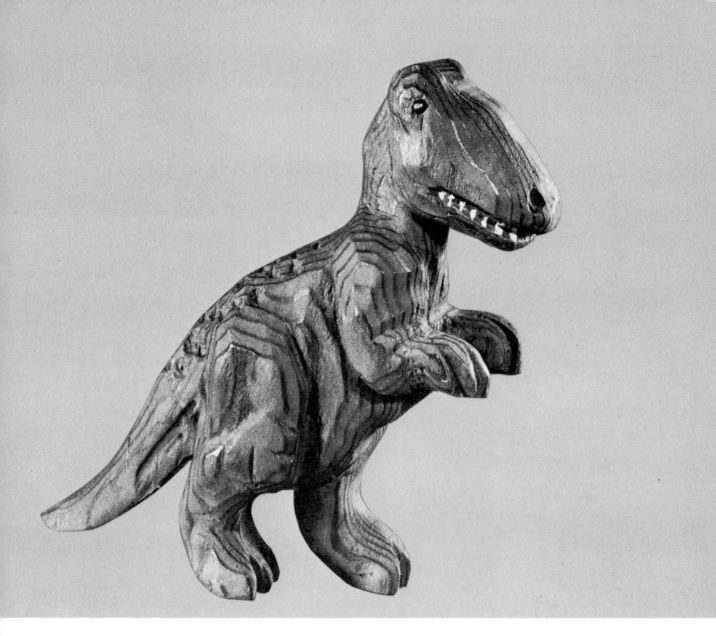

One of the fiercest of the prehistoric animals was the tyranno-saurus. This creature has a large head with a set of sharp teeth in powerful jaws. He often traveled in an upright position.

The eyes, set high on the sides of the head, are small round-headed nails.

After shellacking, paint the mouth red. When this red coat has dried, put in the pointed teeth with white paint.

Teddy
Tyrannosaurus

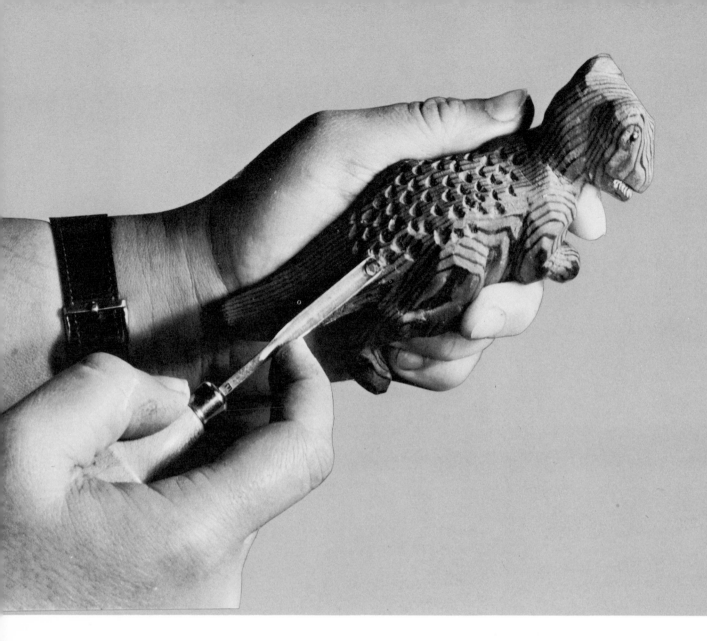

...his back

To give the textured appearance to the back of the tyrannosaurus, use a curved carving chisel. Push the point of the chisel into the wood for a short distance and lift up the chip. Repeat to make a series of half moon depressions on the back of the animal.

Dover Books on Art

MASTERPIECES OF FURNITURE, Verna Cook Salomonsky. Photographs and measured drawings of some of the finest examples of Colonial American, 17th century English, Windsor, Sheraton, Hepplewhite, Chippendale, Louis XIV, Queen Anne, and various other furniture styles. The textual matter includes information on traditions, characteristics, background, etc. of various pieces. 101 plates. Bibliography. 224pp. 7⅞ x 10¾.

21381-1 Paperbound $6.00

PRIMITIVE ART, Franz Boas. In this exhaustive volume, a great American anthropologist analyzes all the fundamental traits of primitive art, covering the formal element in art, representative art, symbolism, style, literature, music, and the dance. Illustrations of Indian embroidery, paleolithic paintings, woven blankets, wing and tail designs, totem poles, cutlery, earthenware, baskets and many other primitive objects and motifs. Over 900 illustrations. 376pp. 5⅜ x 8. 20025-6 Paperbound $5.95

AN INTRODUCTION TO A HISTORY OF WOODCUT, A. M. Hind. Nearly all of this authoritative 2-volume set is devoted to the 15th century—the period during which the woodcut came of age as an important art form. It is the most complete compendium of information on this period, the artists who contributed to it, and their technical and artistic accomplishments. Profusely illustrated with cuts by 15th century masters, and later works for comparative purposes. 484 illustrations. 5 indexes. Total of xi+838pp. 5⅜ x 8½. Two-vols. 20952-0,20953-9 Paperbound $13.00

A HISTORY OF ENGRAVING AND ETCHING, A. M. Hind. Beginning with the anonymous masters of 15th century engraving, this highly regarded and thorough survey carries you through Italy, Holland, and Germany to the great engravers and beginnings of etching in the 16th century, through the portrait engravers, master etchers, practicioners of mezzotint, crayon manner and stipple, aquatint, color prints, to modern etching in the period just prior to World War I. Beautifully illustrated—sharp clear prints on heavy opaque paper. Author's preface. 3 appendixes. 111 illustrations. xviii + 487 pp. 5⅜ x 8½.

20954-7 Paperbound $7.50

ART STUDENTS' ANATOMY, E. J. Farris. Teaching anatomy by using chiefly living objects for illustration, this study has enjoyed long popularity and success in art courses and home-study programs. All the basic elements of the human anatomy are illustrated in minute detail, diagrammed and pictured as they pass through common movements and actions. 158 drawings, photographs, and roentgenograms. Glossary of anatomical terms. x + 159pp. 5⅝ x 8⅜. 20744-7 Paperbound $3.50

COLONIAL LIGHTING, A. H. Hayward. The only book to cover the fascinating story of lamps and other lighting devices in America. Beginning with rush light holders used by the early settlers, it ranges through the elaborate chandeliers of the Federal period, illustrating 647 lamps. Of great value to antique collectors, designers, and historians of arts and crafts. Revised and enlarged by James R. Marsh. xxxi + 198pp. 5⅝ x 8¼.

20975-X Paperbound $5.50

ART ANATOMY, Dr. William Rimmer. One of the few books on art anatomy that are themselves works of art, this is a faithful reproduction (rearranged for handy use) of the extremely rare masterpiece of the famous 19th century anatomist, sculptor, and art teacher. Beautiful, clear line drawings show every part of the body—bony structure, muscles, features, etc. Unusual are the sections on falling bodies, foreshortenings, muscles in tension, grotesque personalities, and Rimmer's remarkable interpretation of emotions and personalities as expressed by facial features. It will supplement every other book on art anatomy you are likely to have. Reproduced clearer than the lithographic original (which sells for $500 on up on the rare book market.) Over 1,200 illustrations. xiii + 153pp. 7¾ x 10¾.

20908-3 Paperbound **$5.00**

THE CRAFTSMAN'S HANDBOOK, Cennino Cennini. The finest English translation of IL LIBRO DELL' ARTE, the 15th century introduction to art technique that is both a mirror of Quatrocento life and a source of many useful but nearly forgotten facets of the painter's art. 4 illustrations. xxvii + 142pp. D. V. Thompson, translator. 5⅜ x 8. 20054-X Paperbound **$3.50**

THE BROWN DECADES, Lewis Mumford. A picture of the "buried renaissance" of the post-Civil War period, and the founding of modern architecture (Sullivan, Richardson, Root, Roebling), landscape development (Marsh, Olmstead, Eliot), and the graphic arts (Homer, Eakins, Ryder). 2nd revised, enlarged edition. Bibliography. 12 illustrations. xiv + 266 pp. 5⅜ x 8.

20200-3 Paperbound **$3.00**

THE STYLES OF ORNAMENT, A. Speltz. The largest collection of line ornament in print, with 3750 numbered illustrations arranged chronologically from Egypt, Assyria, Greeks, Romans, Etruscans, through Medieval, Renaissance, 18th century, and Victorian. No permissions, no fees needed to use or reproduce illustrations. 400 plates with 3750 illustrations. Bibliography. Index. 640pp. 6 x 9. 20557-6 Paperbound **$7.95**

THE ART OF ETCHING, E. S. Lumsden. Every step of the etching process from essential materials to completed proof is carefully and clearly explained, with 24 annotated plates exemplifying every technique and approach discussed. The book also features a rich survey of the art, with 105 annotated plates by masters. Invaluable for beginner to advanced etcher. 374pp. 5⅜ x 8. 20049-3 Paperbound **$4.50**

OF THE JUST SHAPING OF LETTERS, Albrecht Dürer. This remarkable volume reveals Albrecht Dürer's rules for the geometric construction of Roman capitals and the formation of Gothic lower case and capital letters, complete with construction diagrams and directions. Of considerable practical interest to the contemporary illustrator, artist, and designer. Translated from the Latin text of the edition of 1535 by R. T. Nichol. Numerous letterform designs, construction diagrams, illustrations. iv + 43pp. 7⅞ x 10¾. 21306-4 Paperbound **$3.00**

AFRICAN SCULPTURE, Ladislas Segy. 163 full-page plates illustrating masks, fertility figures, ceremonial objects, etc., of 50 West and Central African tribes—95% never before illustrated. 34-page introduction to African sculpture. "Mr. Segy is one of its top authorities," NEW YORKER. 164 full-page photographic plates. Introduction. Bibliography. 244pp. 6⅛ x 9¼.
20396-4 Paperbound $5.00

CALLIGRAPHY, J. G. Schwandner. First reprinting in 200 years of this legendary book of beautiful handwriting. Over 300 ornamental initials, 12 complete calligraphic alphabets, over 150 ornate frames and panels, 75 calligraphic pictures of cherubs, stags, lions, etc., thousands of flourishes, scrolls, etc., by the greatest 18th-century masters. All material can be copied or adapted without permission. Historical introduction. 158 full-page plates. 368pp. 9 x 13. 20475-8 Paperbound $7.95

DRAWINGS OF MUCHA, Alphonse Maria Mucha. 70 large-sized illustrations (including 9 in full color) survey the surprisingly cohesive expanse of Mucha's draftsmanship. Original plans, ideas, etc., for such works as "The Seasons," famous poster for the St. Louis World's Fair, drawings of Sarah Bernhardt, etc. Adds new power to the resurgence of critical acclaim for Mucha's art. 75pp. 9⅜ x 12¼. 23672-2 Paperbound $4.50

FRENCH OPERA POSTERS 1868–1930, Lucy Broido. 53 posters (32 in full color) cover gaiety and epic passions of French opera of La Belle Epoque. Chéret, Steinlen, Grasset and 30 other artists create posters for Massenet, Offenbach, Delibes, Fauré, Février and others. Introduction, extensive notes by Lucy Broido. 96pp. 9⅜ x 12¼. 23306-5 Paperbound $6.00

DESIGN FOR ARTISTS AND CRAFTSMEN, Louis Wolchonok. Recommended for either individual or classroom use, this book helps you to create original designs from things about you, from geometric patterns, from plants, animals, birds, humans, landscapes, manmade objects. "A great contribution," N. Y. Society of Craftsmen. 113 exercises with hints and diagrams. More than 1280 illustrations. xv + 207pp. 7⅞ x 10¾.
20274-7 Paperbound $6.50

HANDBOOK OF ORNAMENT, F. S. Meyer. One of the largest collections of copyright-free traditional art: over 3300 line cuts of Greek, Roman, Medieval, Renaissance, Baroque, 18th and 19th century art motifs (tracery, geometric elements, flower and animal motifs, etc.) and decorated objects (chairs, thrones, weapons, vases, jewelry, armor, etc.). Full text. 300 plates. 3300 illustrations. 562pp. 5⅜ x 8. 20302-6 Paperbound **$6.95**

THREE CLASSICS OF ITALIAN CALLIGRAPHY, Oscar Ogg, ed. Exact reproductions of three famous Renaissance calligraphic works: Arrighi's OPERINA and IL MODO, Tagliente's LO PRESENTE LIBRO, and Palatino's LIBRO NUOVO. More than 200 complete alphabets, thousands of lettered specimens, in Papal Chancery and other beautiful, ornate handwriting. Introduction. 245 plates. 282pp. 6⅛ x 9¼. 20212-7 Paperbound **$4.50**

THE COMPLETE BOOK OF SILK SCREEN PRINTING PRO-DUCTION, J. I. Biegeleisen. Here is a clear and complete picture of every aspect of silk screen technique and press operation—from individually operated manual presses to modern automatic ones. Unsurpassed as a guidebook for setting up shop, making shop operation more efficient, finding out about latest methods and equipment; or as a textbook for use in teaching, studying, or learning all aspects of the profession. 124 figures. Index. Bibliography. List of Supply Sources. xi + 253pp. 5⅜ x 8½.

21100-2 Paperbound **$4.50**

A HISTORY OF COSTUME, Carl Köhler. The most reliable and authentic account of the development of dress from ancient times through the 19th century. Based on actual pieces of clothing that have survived, using paintings, statues and other reproductions only where originals no longer exist. Hundreds of illustrations, including detailed patterns for many articles. Highly useful for theatre and movie directors, fashion designers, illustrators, teachers. Edited and augmented by Emma von Sichart. Translated by Alexander K. Dallas. 594 illustrations. 464pp. 5⅛ x 7⅛.

21030-8 Paperbound **$6.50**

CHINESE HOUSEHOLD FURNITURE, G. N. Kates. A summary of virtually everything that is known about authentic Chinese furniture before it was contaminated by the influence of the West. The text covers history of styles, materials used, principles of design and craftsmanship, and furniture arrangement—all fully illustrated. xiii + 190pp. 5⅝ x 8½.

20958-X Paperbound **$4.00**

THE COMPLETE WOODCUTS OF ALBRECHT DURER, edited by Dr. Willi Kurth. Albrecht Dürer was a master in various media, but it was in woodcut design that his creative genius reached its highest expression. Here are all of his extant woodcuts, a collection of over 300 great works, many of which are not available elsewhere. An indispensable work for the art historian and critic and all art lovers. 346 plates. Index. 285pp. 8½ x 12¼.

21097-9 Paperbound **$8.95**

Dover publishes books on commercial art, art history, crafts, design, art classics; also books on music, literature, science, mathematics, puzzles and entertainments, chess, engineering, biology, philosophy, psychology, languages, history, and other fields. For free circulars write to Dept. DA, Dover Publications, Inc., 180 Varick St., New York, N.Y. 10014.